IMAGES
of America

RHODE ISLAND
SHIPWRECKS

For Capt. Dave Pickering

With best wishes
for smooth seas!

Charlotte Taylor

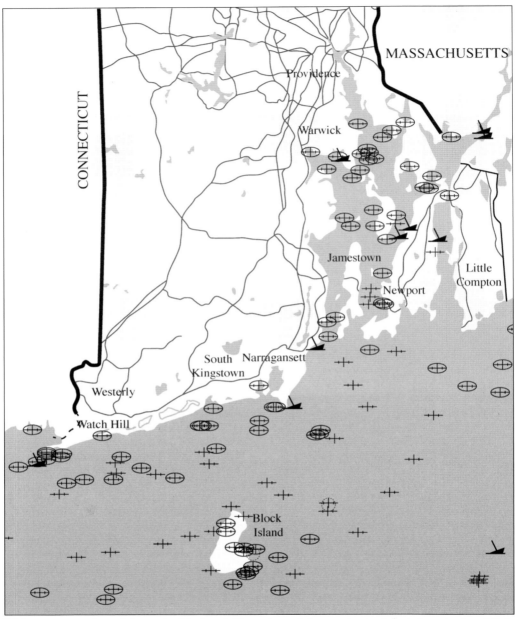

This map was adapted from the National Oceanic and Atmospheric Administration's publicly available chart of wrecks and obstructions for the Rhode Island area. It shows shipwrecks that might constitute hazards to navigation mapped during NOAA's survey work over the past decades. Although it is not a map of every known shipwreck site in the state, it gives a sense of the large number of ships that have been lost and where some of the hot spots are. (Nadine Zaza.)

ON THE COVER: The fishing vessel *Leonora* was swamped at Long Wharf, Newport, on November 20, 1966. (Providence Public Library.)

IMAGES
of America

RHODE ISLAND
SHIPWRECKS

Charlotte Taylor

ARCADIA
PUBLISHING

Published by Arcadia Publishing
Charleston, South Carolina

Printed in the United States of America

Library of Congress Control Number: 2016961363

For all general information, please contact Arcadia Publishing:
Telephone 843-853-2070
Fax 843-853-0044
E-mail sales@arcadiapublishing.com
For customer service and orders:
Toll-Free 1-888-313-2665

Visit us on the Internet at www.arcadiapublishing.com

To the memory of my grandfather, Everett Bellows, who gave up his dream of being a historian to serve in the Navy in World War II.

CONTENTS

ACKNOWLEDGMENTS

Many thanks are owed to the historical societies of Rhode Island that generously shared time and images with me—Bristol, Warren, Newport, New Shoreham, South Kingstown, Charlestown, and Westerly. Thanks also to the Westerly and the Providence Public Libraries, the Boston and New York City Public Libraries, and the staff of the Library of Congress. Dwight Brown generously shared pictures and information from his personal collection, as did Kathy Abbass of the Rhode Island Marine Archaeology Project. Thanks also to the staff of the Rhode Island Historical Preservation and Heritage Commission, the Naval War College Archives, the Naval War College Museum, the National Archives in Boston, the Steamship Historical Society, the Rhode Island Historical Society, Mystic Seaport, the Mariner's Museum in Newport News, the US Army Corps of Engineers, and the New Bedford Whaling Museum. Thanks go to the estate of photographer John Hopf for granting permission to use some of his images here, to Mark Munro for sharing side-scan sonar images, and to Nadine Zaza for her work on the introductory map. Special thanks to Jim Jenney, whose enthusiasm for Rhode Island's shipwrecks is unrivaled, and who has shared his research with the world via the online database of Rhode Island shipwrecks he created. His efforts made the writing of this book much easier than it would otherwise have been, and I am happy that this work will add to this online storehouse of information.

Picture credits include the following:

BIHS	Block Island Historical Society
BPL	Boston Public Library
JHS	Jamestown Historical Society
LOC	Library of Congress
MM	The Mariners' Museum and Park, Newport News, Virginia
MS	Mystic Seaport
NA	National Archives
NAB	National Archives at Boston
NOAA	National Oceanic and Atmospheric Administration
NHHC	Naval History and Heritage Command
NBWM	New Bedford Whaling Museum
PPL	Providence Public Library
RIHPHC	Rhode Island Historical Preservation and Heritage Commission
RIHS	Rhode Island Historical Society
SCM	South County Museum
SSHSA	Steamship Historical Society of America
USACOE	US Army Corps of Engineers
USCG	US Coast Guard
NWCA	US Naval War College Archives
NWCM	US Naval War College Museum
WHS	Westerly Historical Society
WPL	Westerly Public Library

INTRODUCTION

Rhode Island, the Ocean State, has more shipwrecks per square mile than any other state. More than 3,000 ships are known to have come to grief in its waters, and there are certainly many more disasters that were never recorded. The coast of Rhode Island is no more hazardous than any other rocky, foggy shoreline battered by dangerous storms, but the volume of water traffic over the years has left a particularly long record of shipwrecks.

For millennia, the ocean was the easiest way to travel through the region, and Narragansett Bay has been busy with boats for thousands of years. Long before the arrival of Europeans, the Narragansett and Wampanoag travelled extensively in dugout canoes. Though some of these were seafaring vessels large enough to hold as many as 40 people, they did not inspire great confidence in the English. Roger Williams, the founder of Providence, included translations of some useful expressions into the Narragansett language in his 1643 *Key Into the Language of America*, testifying to the risks of sea travel in these canoes: "We shall be drowned," "We overset," "The sea comes in too fast upon us," and "Be of good courage."

Good courage continued to be a necessity for those sailing in Rhode Island waters. Almost as soon as European boats arrived in these waters, they began to run into trouble. In 1624, the Pilgrims from Plymouth heard there was, in the area of modern Warren, Rhode Island, "a Dutch ship driven so high on the shore by stress of weather. . . . that till the tides increased, she could not be got off." This first known European shipwreck was quickly followed by many others. Some sank navigating the reefs off the state's south shore, the passages through Narragansett Bay, and the treacherous coast of Block Island. Rhode Island's written history is filled with accounts of bad luck and bad weather sinking ships and blowing them ashore, and navigational errors resulting in the loss of many more ships.

Other ships were deliberately sunk. During the Revolutionary War, the British sank a fleet of transport ships to blockade Newport Harbor, and scuttled several ships of war to keep them from being captured by the French. After the Navy built the Goat Island torpedo station in 1896, spectators flocked to the shores of Newport to watch derelict vessels blown up during target practice. The last German submarine sunk during World War II, the *U-853*, lies off Block Island, and her final victim, the coal carrier *Black Point*, lies off Point Judith.

Not every shipwreck results in the total loss of the vessel. Many of the ships pictured in this book were got off and refloated, repaired, and returned to service. When a ship became stranded on the shore or on a rocky reef, sometimes it was simply a matter of waiting a few hours for the tide to rise. Other strandings and sinkings called for complicated salvage operations; even some vessels that sank to the bottom in deep water were raised. Vessels that could not be salvaged were left to break apart and rot where they lay, and little is now left of them. The environment of Rhode Island's waters is not kind to shipwrecks, and of these abandoned ships, only a very small number still have any structural integrity. All that remains of most wooden vessels over 100 years old is whatever timbers were buried under a protective layer of silt—exposed wood quickly decomposes. Many wrecked ships were not immediately submerged and were broken to pieces before they settled to the sea floor or washed up onto the beaches. Metal vessels also decay and break apart. Some shipwrecks, like an early 20th century vessel made of concrete, survive well, but for the most part, what remains of the state's older wrecks are hard to find. Almost certainly, there are unknown shipwrecks buried beneath the mud of Narragansett Bay that await discovery.

With the exception of a few calamities involving steamships carrying many passengers, the shipwrecks of Rhode Island have resulted in surprisingly few casualties. In large part, this is due to the heroic efforts of the national and local life-saving services and the volunteers and professional surfmen who risked their own lives to rescue those on board the wrecked vessels, often in winter. Several of the rescues described here were made using a breeches buoy. A line with a weighted projectile would be shot from a gun on shore, which the sailors would grab and use to pull a heavier cable out to the ship. The breeches buoy, which was more or less a life preserver ring with canvas pants attached, could then travel between shore and shipwreck.

The shipwrecks presented in this book are organized by the type of misfortune that befell them—war, strandings, collisions, storms, and explosions. The incidents are generally organized chronologically within each section. These shipwrecks represent only a fraction of the state's total. Obviously, many shipwrecks were not photographed, and though vessels continue to come to grief in Rhode Island, this book ends with the 1960s. The majority of the images therefore come from the second half of the 19th century and the first half of the 20th, which were coincidently the busiest years for the state's waterways. This was the era of the great passenger steamships, offering comfortable transport within the state and to cities to the north and south. This was also the era of the coal barges, lines of which were towed along the coast in large numbers. Sailing vessels were still the primary means for moving commodities. The large number of ships out on the water meant that there were many candidates for misfortune.

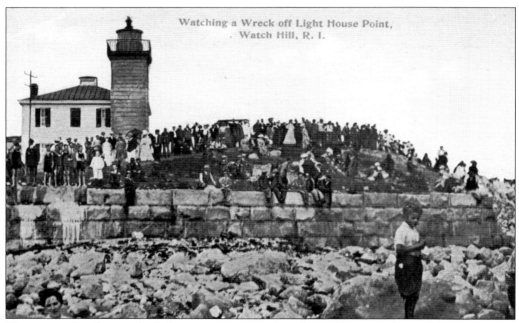

The spectacle of a wrecked ship was guaranteed to draw a fascinated crowd—like the one shown here, which gathered to look at a wreck off Watch Hill. Even long after the event itself, remnants of wrecked vessels on the beaches attracted visitors. The pictures included here offer the opportunity to join the spectators in exploring the state's historic shipwrecks from the comfort of dry land. (RIHPHC.)

One

SHIPS OF WAR

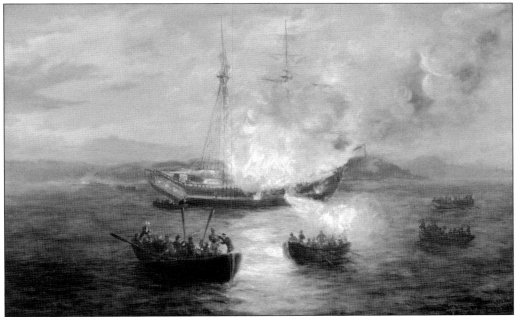

Rhode Island was the site of one of the earliest acts of colonial aggression against the British. Rhode Islanders were active smugglers, evading and at times attacking the British revenue collectors. In the early 1770s, the Royal Navy sent vessels to Narragansett Bay to put a stop to this lack of cooperation. One of these was HMS *Gaspee*. In June 1772, the *Hannah*, a local trading vessel, was pursued up Narragansett Bay by the *Gaspee*. The *Hannah* crossed a shallow spit off the coast of Warwick on a falling tide, and when the larger *Gaspee* followed, she ran aground. When a group of Providence merchants heard the news, they gathered and set off to attack the *Gaspee*. They shot her commander, captured the crew, and set the vessel on fire, a scene imagined in this 1892 painting. Many historians and divers have looked for the remains of the *Gaspee*, but she has yet to be found. (RIHS.)

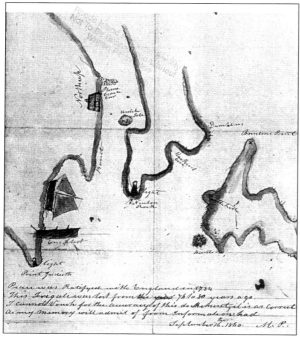

The British occupied Newport during the Revolutionary War and regularly sent out raiding parties to the islands of Narragansett Bay, Block Island, and Long Island for provisions and firewood. One British frigate sent out in 1784 did not make it back to port, going aground on the rocks off Narragansett. Its resting place is labeled "Eng F lost" on this map drawn from the artist's memory in 1860. (RIHS.)

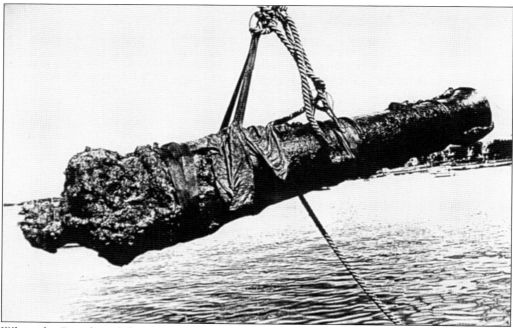

When the British withdrew from Newport, they left many shipwrecks behind, the majority of which were deliberately sunk. In 1778, an approaching French fleet threatened both the British ships and British control of Newport. To keep their ships of war from being captured by the French, the British ran four frigates and three smaller vessels aground and then set them on fire. The sites of three of the frigates were found in the 1970s by divers from the University of Rhode Island, who brought up several of the cannons left on the ships. (RIHPHC.)

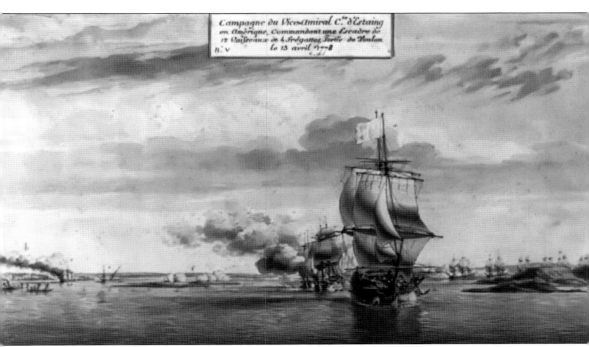

The British also sank a fleet of transports in Newport's Outer Harbor to block the passage between the mainland and Goat Island, protecting the city from French bombardment. Among the transports was the *Lord Sandwich,* formerly Capt. James Cook's ship *Endeavour,* in which he traveled to Australia. The sites of more than half of the transports have been found, although little remains of them. Their masts can be seen sticking up from the water on the left of this image of the French fleet sailing into Narragansett Bay in August 1778. (LOC.)

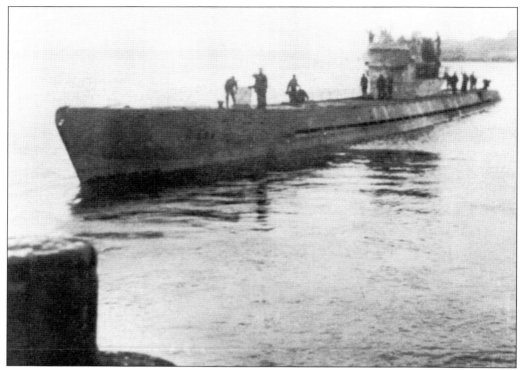

Rhode Island saw no other naval action until World War II, when German submarines began to hunt for targets in the western Atlantic. On May 4, 1945, a few days after Hitler's suicide, all German U-boats were ordered to cease hostilities. The *U-853*, shown here, was patrolling off Rhode Island and either did not get this message or chose to ignore it (NA).

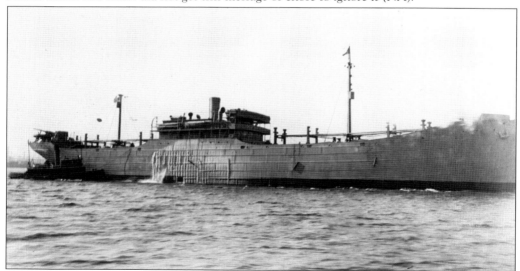

On May 5, 1945, the *U-853* torpedoed the steamer SS *Black Point* (shown here before being sunk) off Narragansett. Most of the officers and crew were able to get off in two boats and a raft, but when the *Black Point* capsized 25 minutes after being struck, eleven crewmen and one armed guard died. She was the last American ship sunk by a U-boat. (NHHC.)

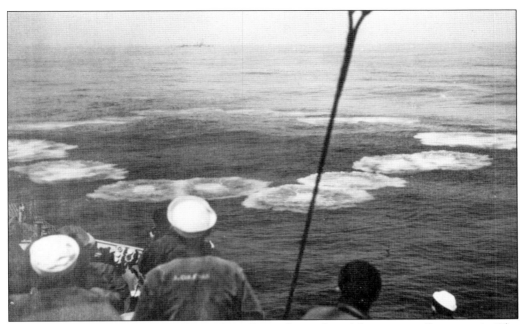

Almost immediately, three naval vessels and one Coast Guard frigate set off in pursuit. The USS *Atherton* made sonar contact with the submarine five miles east of Block Island and began deploying hedgehogs (devices that fired mortars that exploded on contact.) The first round did no damage, but the *Atherton* located the target again a few hours later; this time, oil rising to the surface along with a German naval officer's hat showed she had hit the *U-853*. The Coast Guard vessel *Moberly* joined the attack with more hedgehogs, shown detonating in these images. The *Atherton* can be seen in the background, awaiting its turn to rejoin the attack. (Both, USCG.)

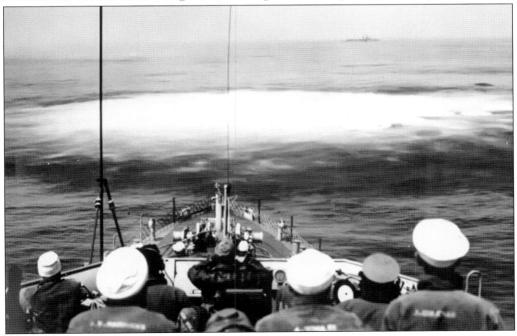

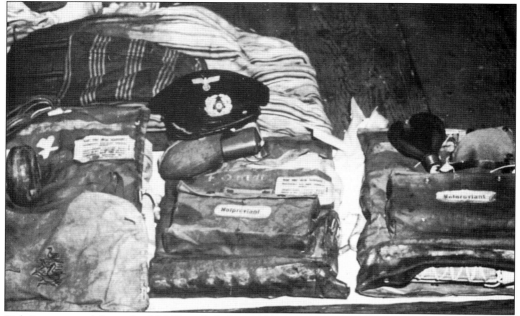

Debris recovered from the *U-853* included a gold braided officer's cap. The cap was awarded to the captain of the *Atherton* in recognition of her outstanding sonar detection. (NA.)

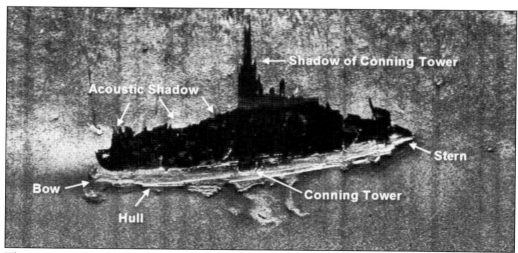

The remains of the *U-853*, shown in this side-scan sonar image, lie in deep water off the coast of Block Island; it is a popular, but dangerous, dive site. (Mark Munro.)

Two

WHEN SHIPS MET SHORE

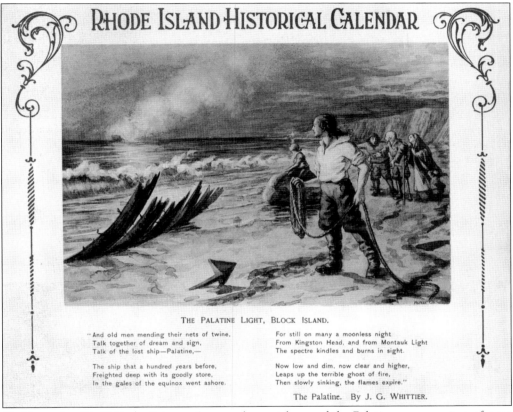

RHODE ISLAND HISTORICAL CALENDAR

THE PALATINE LIGHT, BLOCK ISLAND.

"And old men mending their nets of twine,
Talk together of dream and sign,
Talk of the lost ship—Palatine,—

The ship that a hundred years before,
Freighted deep with its goodly store,
In the gales of the equinox went ashore.

For still on many a moonless night
From Kingston Head, and from Montauk Light
The spectre kindles and burns in sight.

Now low and dim, now clear and higher,
Leaps up the terrible ghost of fire,
Then slowly sinking, the flames expire."

The Palatine. By J. G. WHITTIER.

On December 26, 1738, the *Princess Augusta*, later nicknamed the *Palatine*, was carrying refugees from the German Palatines to Philadelphia when she was caught in a heavy gale a few miles off Rhode Island's coast. The blinding snowstorm limited visibility, and the captain, attempting to steer between Block Island and Long Island Sound, ran the ship on Sandy Point at the northern tip of Block Island. The ship was abandoned and broke apart. In one version of this shipwreck story, the Block Islanders were kind-hearted and saved the passengers. Another version, however, casts the Block Islanders as wreckers who deliberately lured the ship onto the rocks with a false light, murdered the passengers, and set the ship ablaze to conceal their crime. This version was popularized by John Greenleaf Whittier's poem of 1867, "The Wreck of the Palatine," reproduced with a romantic engraving in this mid-20th-century calendar. (RIHS.)

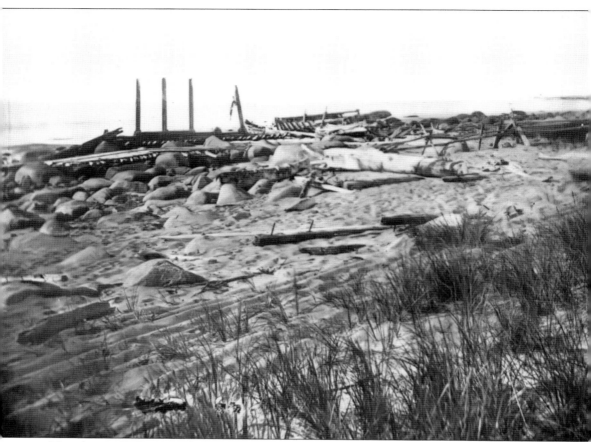

The schooner *Pathway* wrecked in a storm off Charlestown Beach in October 1870. The crewmembers were saved, though one man was injured falling from the rigging. The *Pathway* was a total loss, and the shore became littered with her timbers as she broke apart. (Dwight Brown.)

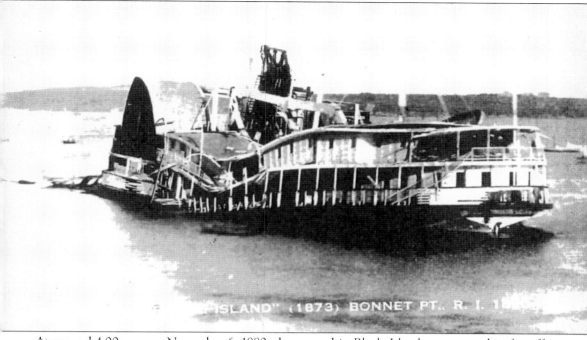

ISLAND" (1873) BONNET PT., R. I. 1

At around 4:00 a.m. on November 6, 1880, the steamship *Rhode Island* ran aground in fog off the shore of Narragansett. The shock of the impact broke both smokestacks loose, sending the starboard stack crashing through several of the upper staterooms, miraculously only injuring one passenger. The battering of the waves against the ship as she lay with her stern acting like a pivot on the rocks caused both the chandeliers in the main saloon to fall, leaving the anxious passengers who had gathered there in darkness. Water began to wash away the loose freight in the hold, and the forward deck began to go to pieces. When daylight came, all the passengers were got off safely. By evening, waves were breaking across her deck. As her bottom was completely knocked out and she was twisting and turning in the waves, there was no hope of getting her off. As the cargo started washing ashore, a gang of wreckers and thieves descended, and a posse of police officers came down from Providence to protect the flotsam. Some of the *Rhode Island's* machinery was successfully salvaged and reused in another vessel of the same name. (SSHSA.)

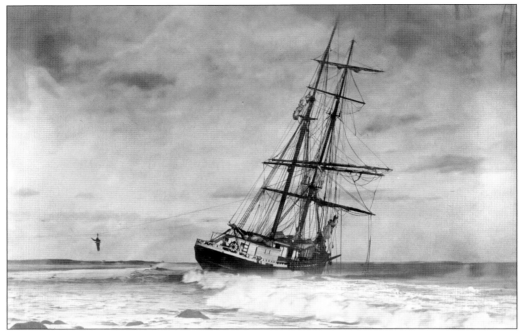

On the evening of November 25, 1886, the brig *Toronto of Windsor*, en route from Cape Breton to New York with a cargo of coal, came ashore in a driving storm on the east beach at Watch Hill. The captain had mistaken the Watch Hill light for the light on Gull Island. Fortunately for the crew, they were very near the US Life-Saving Station. After seven tries, a line for the breeches buoy was successfully fastened, and all were taken off safely. Though the coal was salvaged, the heavy surf, shown below, kept the vessel from being refloated. By December, she was rapidly breaking up, and after her masts and spars were removed, she was left where she lay. (Above, WPL; below, WHS.)

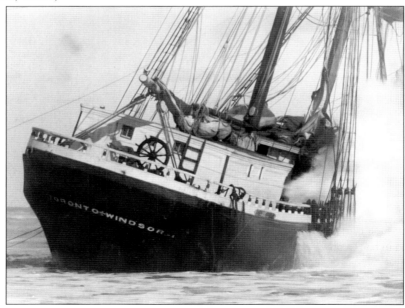

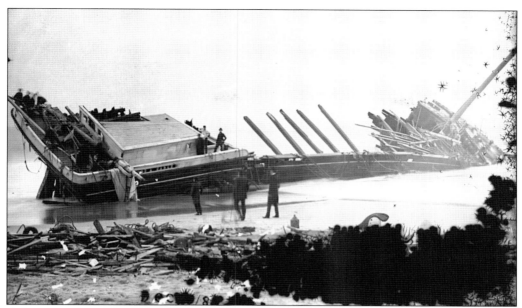

A freezing gale on the night of December 7, 1885, covered the schooner *Fred A. Carle* with ice, making her unmanageable. She stranded on Quonochontaug Beach. Although there were no fatalities during the wreck, there was a fatal coda to the incident. On December 9, three of her crew returned to stay aboard the vessel, but another storm came through and put them in grave danger. Attempting to reach shore again in their own boat, it capsized, and two of the men were drowned. Though efforts were made to refloat the schooner, it was a total loss. (Dwight Brown.)

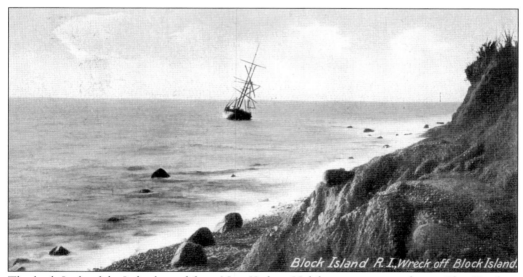

The bark *Lady of the Lake*, bound from New York to Halifax, went aground near Clay Head on Block Island in bad weather on May 15, 1890. She was the fourth ship in six months to go aground in that general area. She quickly became battered by the heavy surf and was abandoned by her captain the next day; she was sold that afternoon for $500 to a Block Islander. As well as the standard salvaging of her rigging, her foremast was removed and used as a flagpole at a nearby mansion. (RIHPHC.)

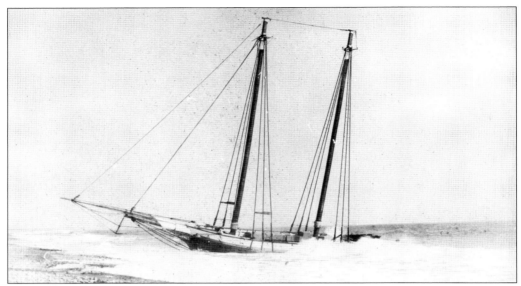

The schooner *Clio Chilcott* came ashore in a severe snowstorm in the early morning of January 16, 1886. All night, the crew had struggled to control their ship and deliberately beached her at daylight to prevent her from foundering out at sea. When the ship stuck fast, the three crew members climbed into the rigging, but one became so cold, his grip failed, and he fell overboard and drowned. The others were rescued in the "life car" brought to the scene by the lifesaving crew at Watch Hill—the car travelled on a sturdy line made fast to the ship. (WPL.)

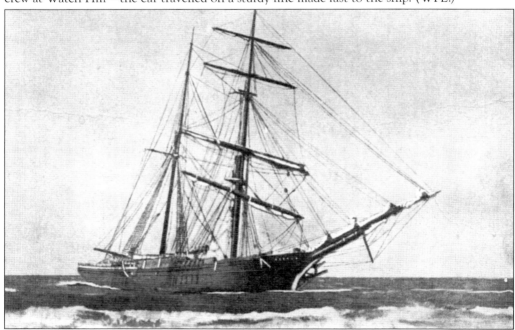

The brigantine *Plover* was en route from New York to Sierra Leone when she went aground on Sandy Point, Block Island, on November 4, 1899. The crew was saved, and though the hold had six or so feet of water in it, most of it had come in through the deck, and a diver was able to patch the leak in her hull. She was refloated a few days later. (RIHPHC.)

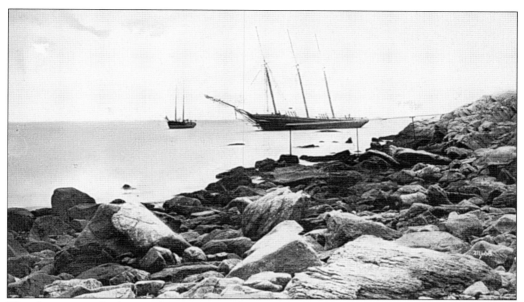

The three-masted schooner *Maggie J. Smith* set off from New York on her final voyage with a cargo of coal for Portsmouth, New Hampshire. On November 10, 1887, in rough seas kicked up by a southwest gale, she hit the reef off Bass Rock two miles to the south of the Narragansett Pier Life-Saving Station. The captain apparently mistook a light in a house on the beach for Beavertail Light and ended up aground about 100 yards from shore. The *Maggie J. Smith* had an auxiliary steam engine and used it to sound loud whistles of distress, which were heard by a man on shore. The crew were rescued and given "stimulating drinks." (Sallie W. Latimer.)

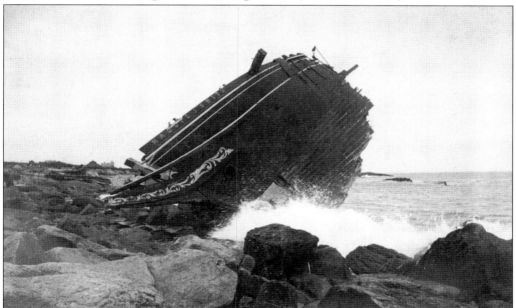

The surfmen boarded the vessel the next day to retrieve their gear and recover the personal effects of the crew. The *Maggie J. Smith* could not be saved, and her wooden hull was eventually picked up by the waves and tossed ashore. (RIHS.)

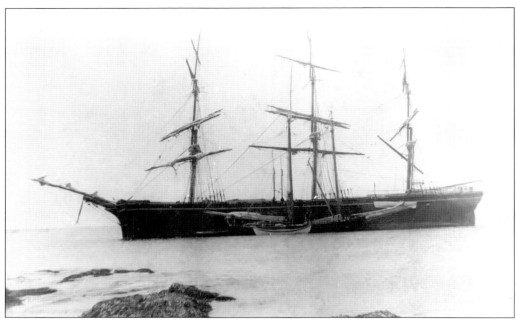

The *Lydia Schofield* had almost completed her voyage from New Orleans to Providence when she fell victim to the rocks near Castle Hill, Newport, in a dense fog on April 20, 1891. Her captain had been staying out in the open ocean for the previous four days waiting for the fog to lift and decided to make a run for Newport during a brief break, which unfortunately did not last long enough. According to the *Newport Daily News*, the fog lifted again "about the time the ship got comfortably settled on the rocks." A work gang of about 85 men set to work recovering her valuable cargo of cotton and oil using a steam-powered hoist, and they were largely successful, but the *Lydia Schofield* could not be freed and was left to break apart. (Both, PPL.)

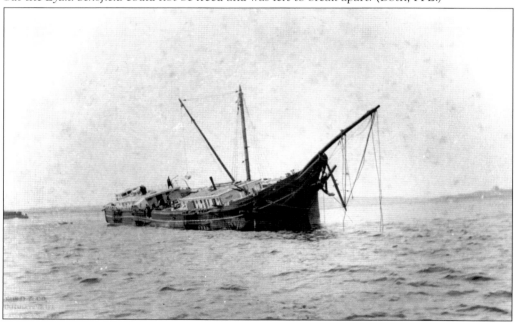

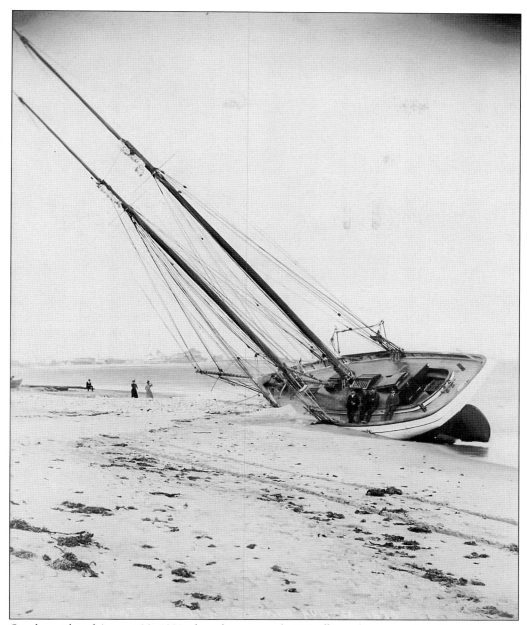

On the night of August 28, 1893, the schooner yacht *Priscilla*, a pleasure craft sailing from New Haven to Newport, went ashore on the rocks at Napatree Point, Westerly. The local lifesaving service got the crew and passengers safely ashore, including, as the *Boston Globe* noted, "some lady passengers." The next day, hurricane force winds blew, and soon, the *Priscilla*, which had seemed salvageable in the morning, was in danger of becoming a total wreck. She survived, however, and was refloated a month later. (WPL.)

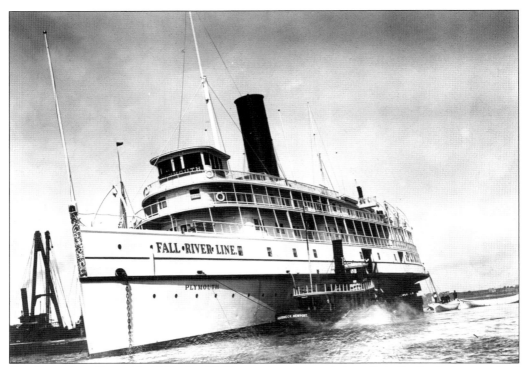

On the night of June 18, 1894, the SS *Plymouth* was stranded on Spindle Rock, just south of Rose Island, in dense fog. This was a dangerous point where two other steamships (*Fall River* and *Conanicut*) had struck rocks in the past. Her captain, Elisha Davis, a man nicknamed "Fog Eater" for his ability to navigate in zero visibility, had not lived up to his reputation. The *Plymouth* was stuck hard enough that efforts to pull her off with tugboats, shown above, were unsuccessful. A diver went down to inspect the situation and found that she was caught solidly on a jagged reef. The salvage firm Merritt-Chapman & Scott came to her rescue; the company's derricks are shown below freeing her. (Above, PPL; below, MS.)

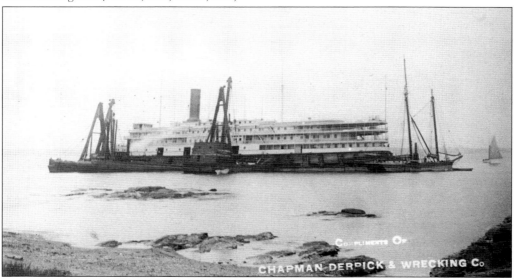

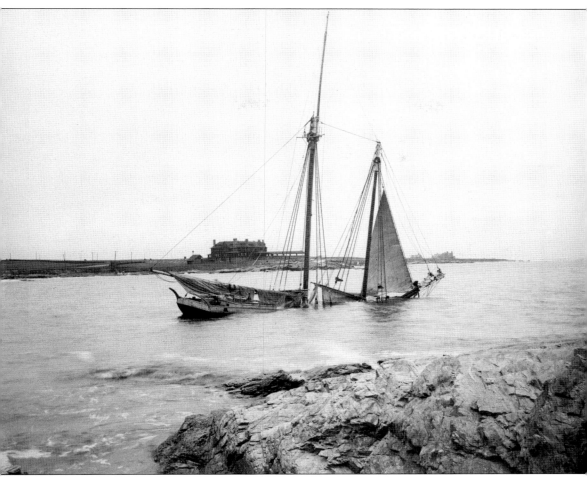

The schooner *Eva L. Leonard* went aground off Castle Hill, Newport, when a brief but intense snowstorm on January 13, 1895, caused the captain to lose his bearings. A burglar alarm, which proved to be false, had brought a force of policemen out to the area, who saw the wrecked vessel and summoned the Price's Neck lifesaving crew. When the life savers arrived at the scene, waves were breaking over the vessel, and there was no sign of life on board. However, on the fourth attempt to shoot a lifeline to the boat, an individual appeared and secured it, and the captain and three men were brought ashore in a breeches buoy—the first time this particular lifesaving crew had had occasion to use it. The men had considered swimming to the nearby shore, but were understandably afraid of freezing to death once they got there. Much of the cargo of coal was salvaged, but the schooner herself was a total loss. (MM.)

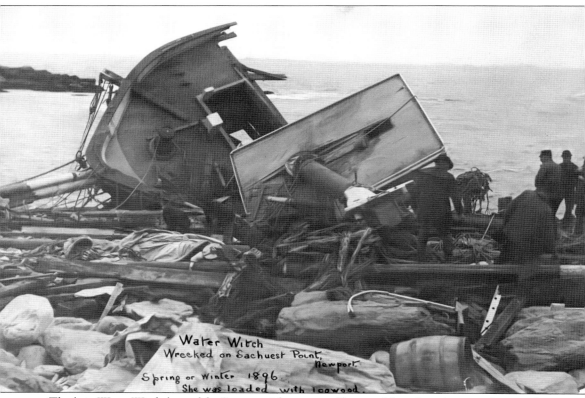

The brig *Water Witch*, bound for Boston with a cargo of logwood from Jamaica, was driven ashore on Sachuest Point in Newport during the evening of March 18, 1896. She struck heavily, throwing some of the crew overboard; they were able to swim to safety. Those still on board were washed ashore by the heavy surf. The *Water Witch* was a total loss. (Newport Historical Society.)

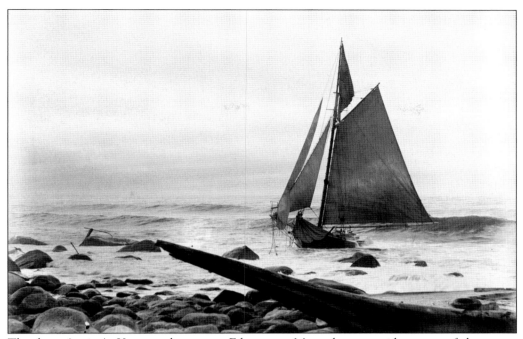

The sloop *Annie A. Kruse*, on her way to Edgartown, Massachusetts, with a cargo of clams, was wrecked on Sheffield Point at Quonochontaug around one in the morning of August 18, 1899. The local lifesaving team made it to the scene an hour later, but the captain and the single crewman had already made it through the breakers to land. (WHS.)

Though the *Annie A. Kruse* was fairly intact when she first hit land, and it seemed possible to salvage her, the stormy seas made it impossible to save the vessel. Her sails ripped apart, and she gradually broke up. (Dwight Brown.)

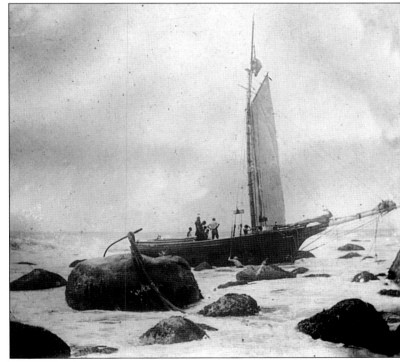

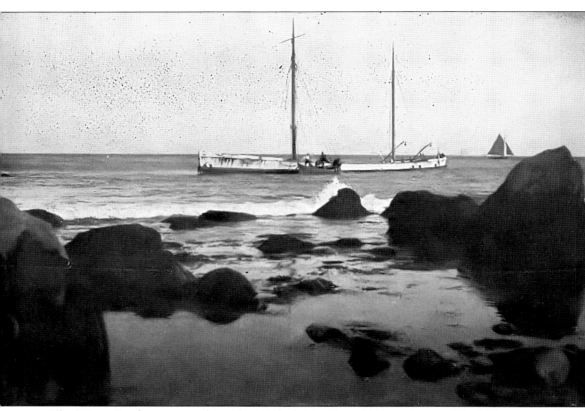

The US tug *Leyden* went on the rocks off Block Island at midday on January 22, 1903, a victim of the fog that was responsible for most of the wrecks off the island's south shore. Six of the thirty-five crewmembers made the questionable decision to seek land in one of the ship's boats; it was dashed to pieces a short distance from shore. The Block Island lifesaving crew got off the other 26 with much difficulty via the breeches buoy. The *Leyden* began to go to pieces in the pounding surf just half an hour after she struck. The US Life-Saving Service annual report for that year shares the fact that all the rescued men who needed dry clothes were given them. (RIHPHC.)

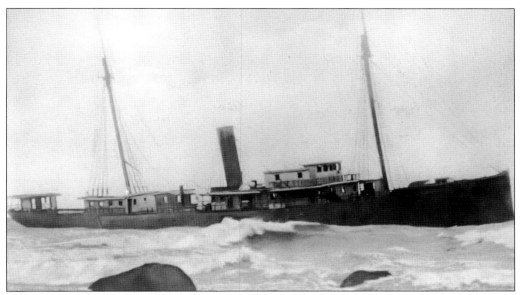

The *Spartan* fell victim to early morning fog off Block Island on March 19, 1905. The chances of saving the iron steamship seemed good, so the captain declined aid, hoping to work her afloat again at high water. His hopes were dashed when the waves picked up at nightfall and began to break over the ship, and so signals of distress were raised. (SSHSA.)

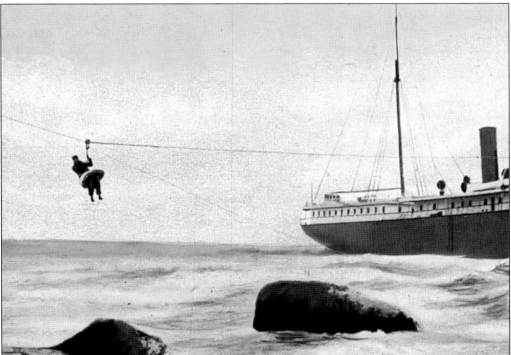

The local lifesaving crew quickly came to the rescue and took the crew off with the breeches buoy, as shown here. It became apparent that the sharp rocks had torn the bottom of the ship so severely that she could not be saved, and the *Spartan* was abandoned where she had struck. (RIHPHC.)

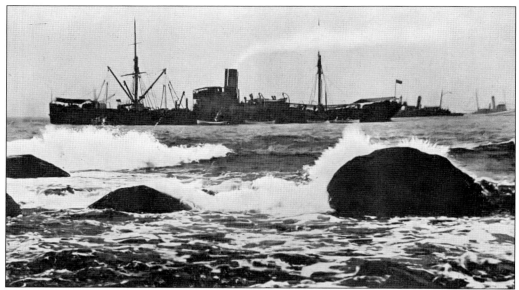

The naval collier *Nero* ran ashore on the south coast of Block Island in August 1906. When she failed to float free at high tide that day, it was decided to call in professional salvors from New London, and her sea traps were opened to fill her with water so that she would settle more heavily on the bottom and not be battered to pieces by the waves. Only the forward compartment of her hull was damaged, and once her cargo of 4,000 tons of coal was removed, she was freed from the rocks. (RIHPHC.)

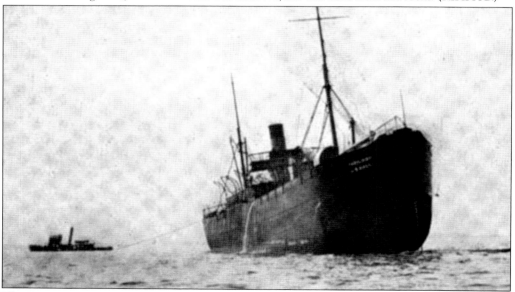

The *Nero* went aground again a few years later in July 1909 on Brenton's Reef off Newport in heavy fog. Big wrecking tugs tried to pull her free, as shown here, but she was too tightly stuck to the rocks. The Navy engaged the services of inventor John Arbuckle, who had designed a method of raising vessels using compressed air. All the openings in the various holds were hermetically sealed, and the compressed air pumped in to drive the water out of the rents in the hull. Once she was dry inside, she was successfully refloated. *Nero* was then towed to New York for repairs, with compressed-air technicians constantly at work inside her to keep the water out. (Goldschmidt Thermit Company.)

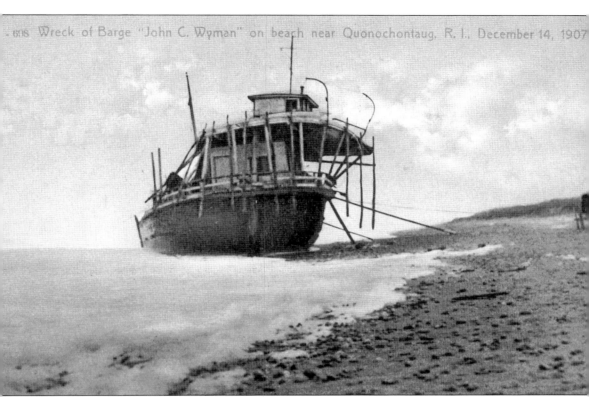

Wreck of Barge "John C. Wyman" on beach near Quonochontaug. R. I., December 14, 1907

On December 14, 1907, the tug *Hercules*, headed from Newport with four empty coal barges in tow, struck a submerged wreck (possibly the remains of the *Larchmont*) off the south coast of Rhode Island. A gale was blowing with fierce snow falling, and to save the tug, her captain beached her three and a half miles northeast of the Watch Hill Life-Saving Station. The crewmembers from that station, joined by men from the Quonochontaug station (who rowed five miles in their lifeboat to the scene), saved the crews of the tug and the barges after 10 hours of struggle in the gale. The four barges had anchored off the beach, but dragged ashore; all four were a total loss. The *John C. Wyman*, one of the four, is shown here breaking apart on the beach. (RIHPHC.)

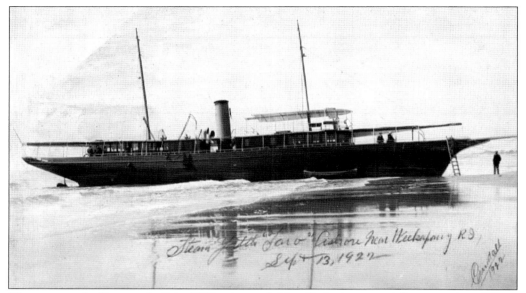

The steam yacht *Taro* was built in 1890 to be a rich New Yorker's personal floating palace. When she was stranded on the dunes of the Westerly beach at Weekapauge in 1922, her age worked against her. She was apparently so old it was impossible to pull her off in one piece, and she was left to break apart. (Dwight Brown.)

The USS *Cyane* is shown at the beginning of January 1922 undergoing repairs after having accidently rammed into a stone seawall while coming into the naval torpedo station in Newport. She was repaired by early March and returned to service. (NHHC.)

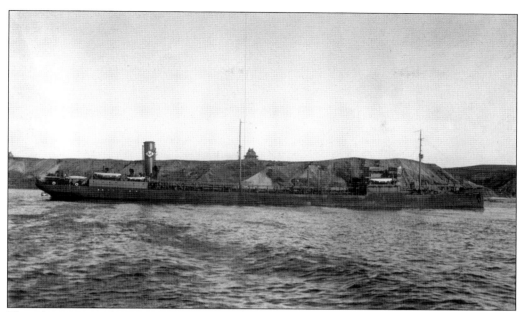

The oil steamer *Swift Star* became another casualty of Block Island's rocky coast and foggy weather on October 10, 1922. The crew at first remained with the ship, and at 6:00 a.m. the next morning, a tug from New London tried to assist but was unable to pull her free. Conditions worsened onboard. The pumps fouled with sand, and two boilers cut out. The engine room and fire room were flooding. At 10:00 a.m., the crew realized they would have to abandon ship by nightfall. The captain and some of the crew left in one of the ship's boats. Fortunately for the 33 men left on board, a passing submarine, *N-2*, stopped to pick them up. Once they were all packed "like sardines" into the sub, they were safely landed on Block Island. The fog lifted in the afternoon, and according to the World Wide Wireless report, the "usual curious natives were gathered at the beach" where the *Swift Star* could be seen just off shore. (Both, MS.)

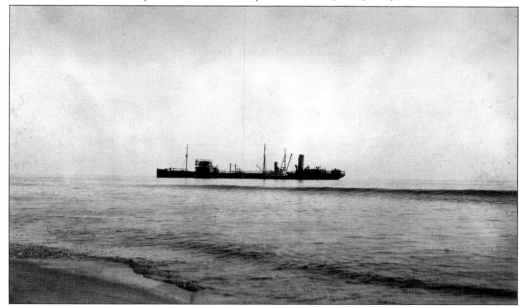

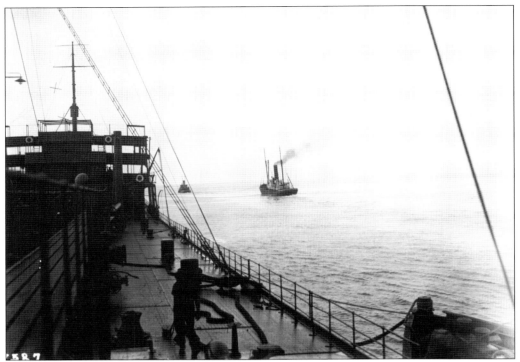

The salvage company of Merritt-Chapman & Scott was soon on the scene and pulled the *Swift Star* free. (MS.)

Once the damage to her mangled hull was repaired, the *Swift Star* went back to sea, only to disappear a year later while passing through the Panama Canal. (MS.)

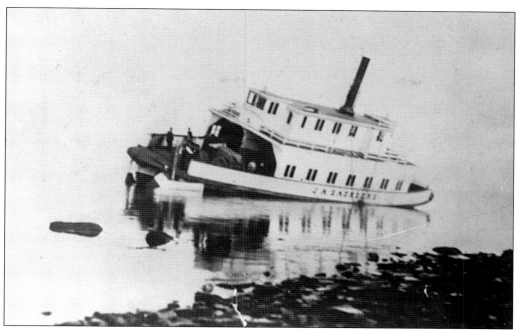

Even vessels that were plying well-known routes along less dangerous shorelines than the coasts of Block Island and Westerly could come to grief when the tide was low, as the stranding of the ferry boat *J.A. Saunders* on Dutch Island around 1920 shows. She was refloated at high tide with little harm done. (JHS.)

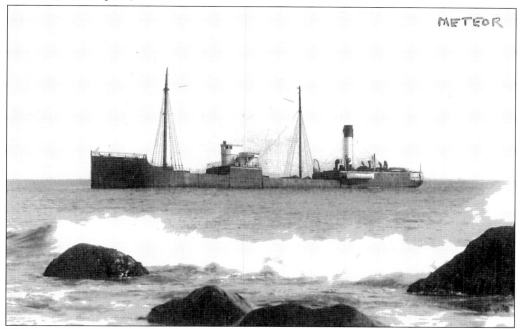

The steamship *Meteor*, loaded with 3,500 tons of coal, went aground off the south side of Block Island in the fog on July 10, 1926. Firmly embedded on the rocks, and pounded by rough seas before she could be got off, she was in the end a total loss. (SSHSA.)

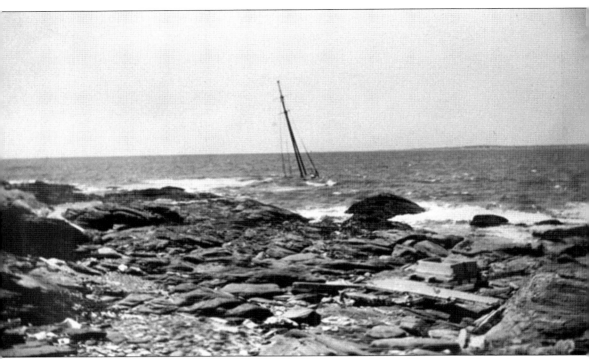

The fishing boat *Eugenia*, carrying $2,500 worth of mackerel from Gloucester, Massachusetts, to Newport, hit an uncharted rock off Beavertail, Jamestown, in the middle of the night on July 2, 1928. Shortly after, the crew abandoned ship and took to the seine boat to reach shore. *Eugenia* foundered, rolling partially onto its side as it slid into deeper water. Soon, her spars and rigging began to wash ashore, followed shortly by the mackerel when the hatches broke loose. The crowd of people who had come to see the wreck were apparently astounded by the vast quantity of mackerel that covered the shore. *Eugenia* was a total loss. (JHS.)

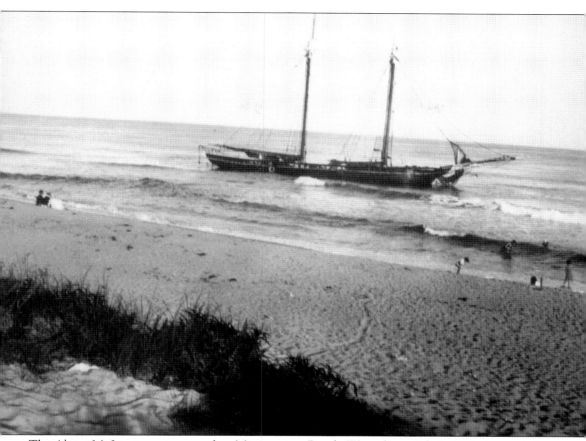

The *Altana M. Jagger* went aground on Misquamicut Beach, Westerly, on July 8, 1932. A crowd of over 100 people came down to the beach to admire the shipwreck. By the time this picture was taken a few weeks later, she had become less of a spectacle, though she was still an impressive sight. (NBWM.)

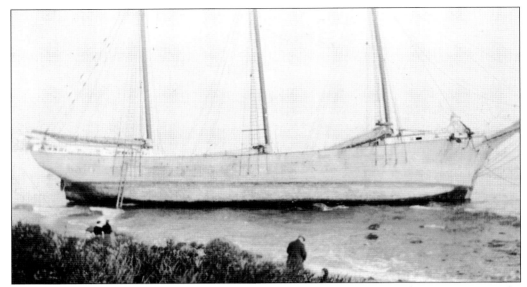

The Granville R. Bacon ran ashore on a sand bar off Weekapaug, Westerly, in a storm on the night of December 20, 1933, after her captain mistook a streetlamp for a light on a passing vessel. Her crew of six were taken off the next day; the vessel was a total loss. (WPL.)

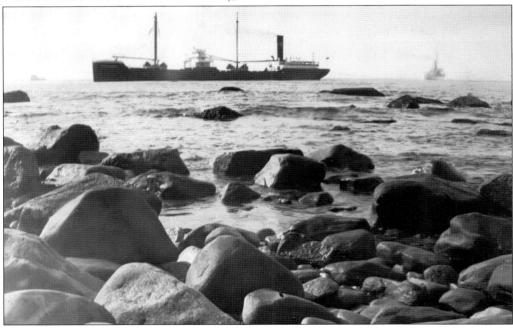

The freighter *Malamton* went aground about 1,000 feet off the southeastern end of Block Island on April 26, 1938. She was in no immediate danger, as the seas were not heavy, and only her forward hold was taking on water. Two Coast Guard boats stood by in case conditions changed and the crew needed rescue, and salvage tugs quickly steamed from New York and Boston. Once the ship's cargo of telegraph poles, crossbars, and railroad ties was taken off to lighten her, she was pulled free of the rocks. Five years later, her luck ran out for good when, under the name *Minotaur*, she was torpedoed in the South Atlantic. (BIHS.)

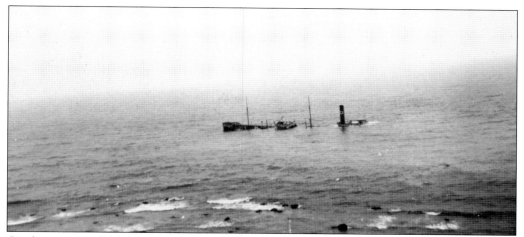

On the evening of February 10, 1939, the tanker *Lightburne* lost its way in dense fog and struck the rocky shoals off the south coast of Block Island, just south of the Block Island Southeast Lighthouse. The crew of the *Lightburne* had heard the fog signal from the lighthouse but thought they were still several miles off shore. In what the *New York Times* called "one of the most spectacular ship rescues in recent years," Coast Guard surfmen were on the site within two hours, braving the pounding surf and saving all 37 crewmembers. The next day, a signal flare falling from the ship ignited the oil that had spilled into the water, but the wind blew the flames away from the 92,000 barrels of bulk oil on board. After some of the fuel was offloaded, the ship was dynamited. The *Lightburne's* captain was ultimately found at fault for failing to take adequate precautions in bad weather. (PPL.)

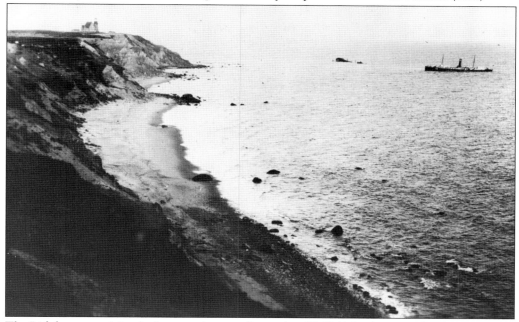

The *Lightburne* was joined a few years later on September 25, 1941, by the steamship *Essex*. Caught in stormy seas that threatened to swamp his vessel, the captain of the *Essex* sent out an SOS, saying she was rapidly filling with water. He then deliberately ran her aground on the south coast of Block Island. This image shows both the *Essex* (right) and the *Lightburne* off Block Island's South East Light (upper left). (MM.)

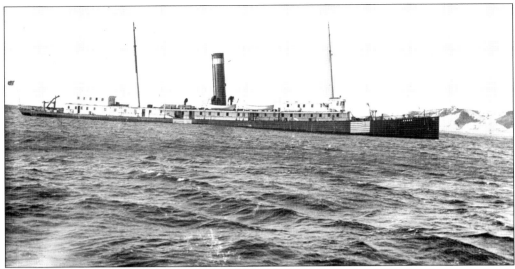

When the US Coast Guard cutter *Argo* arrived in response to the SOS, the *Essex* was firmly aground with 30 feet of water in her engine room. The Coast Guard cutter took the 41-man crew off the vessel, which was being battered by the rough sea. (MM.)

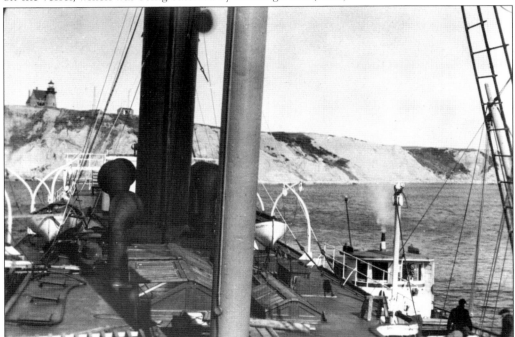

In October, it still seemed possible that the *Essex* might be saved, and she was visited by potential salvors. However, the prices proposed for the salvage work were greater than the insurance value of the ship. Bad weather in November rendered the cost a moot point, as a severe gale came through early that month and stove a fresh hole in her bottom, and a second bad storm in December swept away all that was left of her superstructure. At that point, about 3,000 of the 7,000 bales of cork that were her main cargo had been removed, leaving plenty to be washed ashore for the islanders to collect. (MM.)

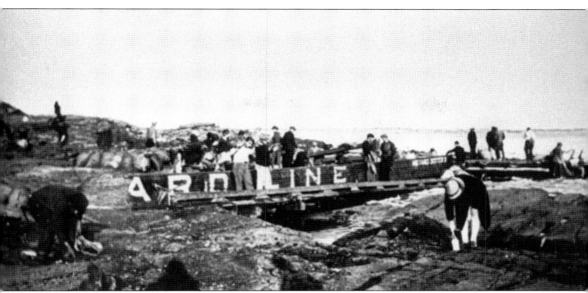

Coal barges, strung in a line behind a towing vessel, were common sights on Rhode Island waters in the early 20th century and quite often provided windfalls for shoreline scavengers when the tow lines broke. Two coal barges from the Howard Company (one still reading "–ard Line") went ashore in an October storm in 1930 at Lucky Strike Rock, Jamestown, and the town residents were quick to harvest as much of the coal as they could. (JHS.)

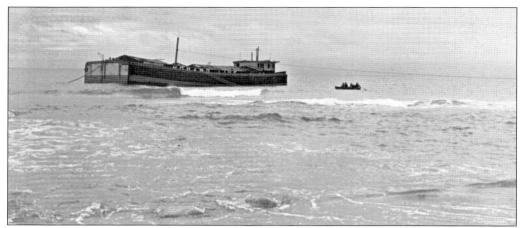

Ten years later, more of the Howard Company's coal barges came to grief off the shore of South Kingstown. The tug *Charles P. Greenough* left New London, Connecticut, on December 4, 1940, pulling three box barges: the *Thomas H. O'Leary*, the *Katherine Howard*, and the *Agnes Howard*, loaded with coal for Boston. At first the weather was tolerable, but conditions worsened, with wind and snow moving in. A little after 7:00 p.m., as the convoy was passing the south beaches of Rhode Island, the captain of the tug called the Coast Guard station at Point Judith to ask if they could send a vessel to stand by. He was right to be worried. The heavy seas broke through the hatches of the *Thomas H. O'Leary*, swamping and sinking her. When the towing hawser to the *Katherine Howard* (pictured) broke, she dropped her anchor, which held for about an hour or more before it began to drag. The anchor chain parted, and the *Katherine Howard* was sunk and destroyed in the high seas; her wreckage washed ashore. (SCM.)

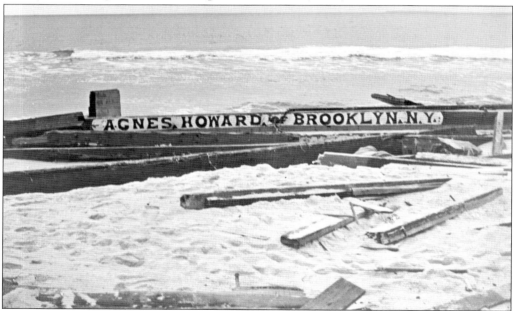

The *Agnes Howard* was likewise no match for the rough seas on her own; she smashed to bits on a ledge, and her tender drowned. The married couple who lived on board the *Thomas H. O'Leary*, however, were more fortunate and were rescued by Coast Guardsmen who hauled them from the water after their vessel went down. (SCM.)

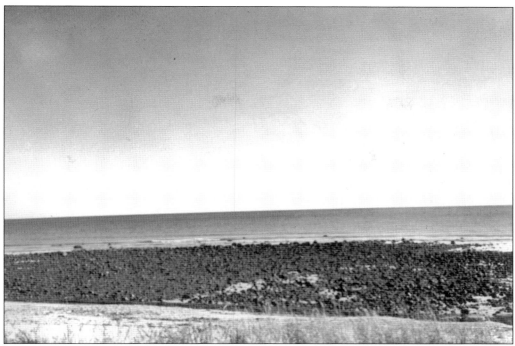

The beach was practically black with coal, and locals took advantage of the opportunity to stock up for the winter. The roads were jammed with coal hunters, shown below shoveling it into bushel baskets and sacks. The wreck of the Thomas O'Leary is visible in the background, and the wreck of the *Agnes Howard* is on the right. (Both, SCM.)

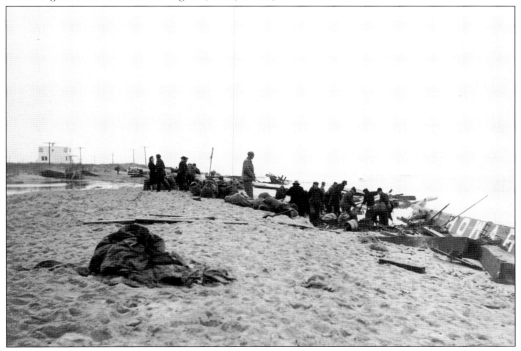

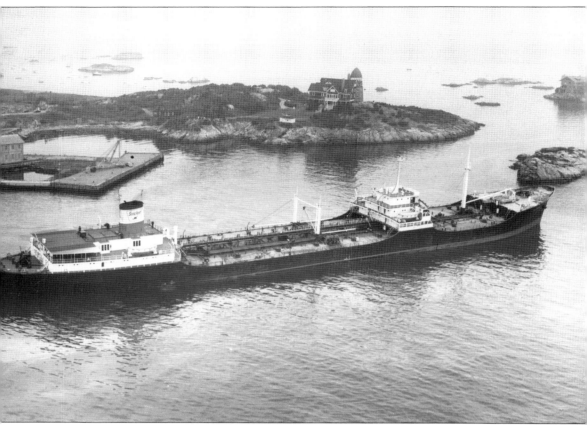

The oil tanker *Thirtle* went aground on the rocks south of Fort Wetherill, Jamestown, early in the morning of September 1, 1961. The rocks tore through her hull, and the Coast Guard estimated that by midday, she had lost 28,000 barrels of oil and was still leaking. Approximately 339,000 gallons of bunker oil escaped from the tanks of the vessel in the end, and the thick, heavy oil coated local beaches and docks for weeks before it was removed. The Sinclair Refining Company, which operated the tanker, made payments totaling $65,990 to defray the clean-up costs incurred by the state and the municipalities of Newport and Jamestown. This payment, reached by negotiation with no litigation, was the first of its kind in Rhode Island. (JHS.)

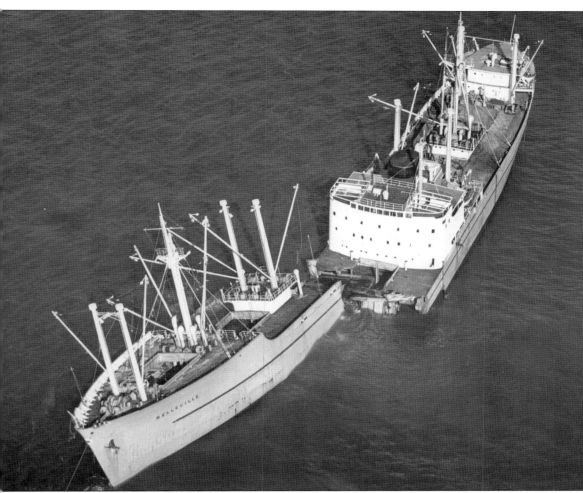

The *Belleville*, a Norwegian freighter, went aground just west of Seal Rock, Newport, at about 5:30 a.m. on September 24, 1957. The captain placed the blame on the pilot, who had apparently mistaken Beavertail Light for Brenton Reef Lightship, though visibility was excellent. The ship's radar, radio directional finder, and depth recorder were not operating at the time. The pilot, who admitted he was navigating by sight, was suspended for six months. (MM; photograph by John Hopf.)

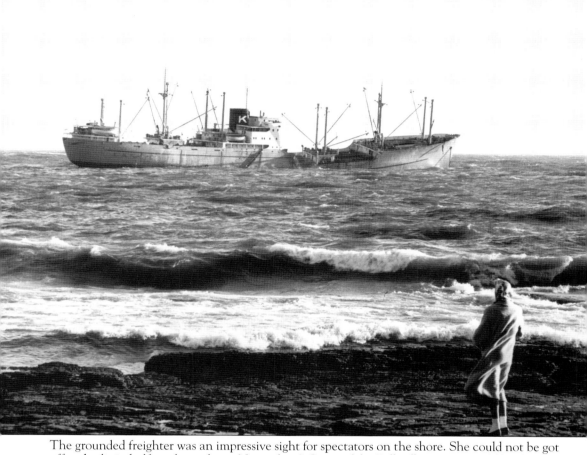

The grounded freighter was an impressive sight for spectators on the shore. She could not be got off and split in half on the rocks on November 9. Some of the *Belleville* was successfully salvaged, but much of her was left to disintegrate on the ocean floor. (JHS; photograph by John Hopf.)

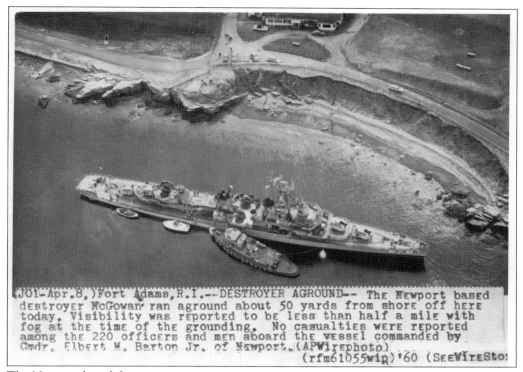

(.JÓl-Apr.8,)Fort Adams,R.I.--DESTROYER AGROUND-- The Newport based destroyer McGowan ran aground about 50 yards from shore off here today. Visibility was reported to be less than half a mile with fog at the time of the grounding. No casualties were reported among the 220 officers and men aboard the vessel commanded by Cmdr. Elbert M. Barton Jr. of Newport.(APWirephoto)
(rfm61055wip)'60 (SeeWireStor

The Newport-based destroyer USS *McGowan* ran aground about 50 yards offshore of Fort Adams in a morning fog on April 8, 1960. Two tugs began the work of pulling her off at noon, and by 3:00 p.m., the tide had risen her two feet, and she floated free. (Newport Historical Society.)

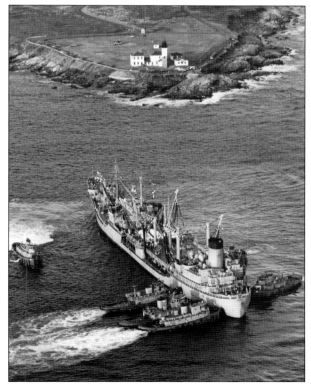

The USS *Severn* hit Newton Rock, off Beavertail Light, on February 9, 1968. The *Severn* was the US Navy's fleet oiler for the region but was fortunately carrying no cargo when it went aground. It was gotten off with the help of multiple tug boats within 24 hours. (Newport Historical Society; photograph by John Hopf.)

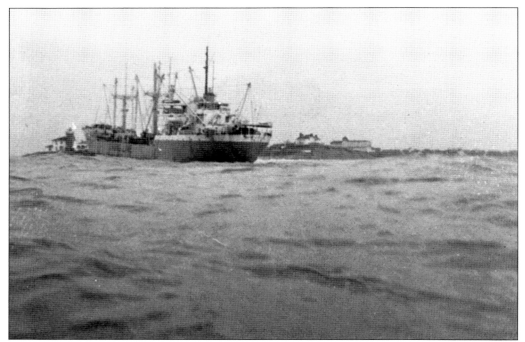

In 1962, the Norwegian *Leif Viking* ran aground on Gangway Rock off Watch Hill Point, visible in the background of this image, due to the captain having overestimated the speed of the vessel and changing course too soon. The vessel was in no immediate danger of breaking up, and the captain and crew stayed with her until she was pulled free. Although she was taken to a Brooklyn shipyard for repairs, she ended up being scrapped instead. (Both, Dwight Brown.)

Three

When Ships Met Ships

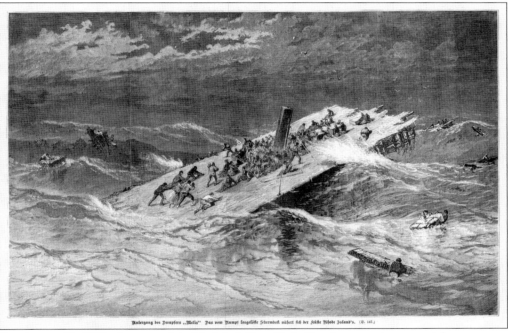

On August 29, 1872, the steamship *Metis* left New York City for a routine overnight voyage to Providence, Rhode Island, with over 100 passengers on board. At around 3:30 a.m. the next morning, the *Metis* was about four miles south of Watch Hill when the crew saw the lights of the schooner *Nettie Cushing.* They held their course, thinking there was room for the two ships to pass each other safely, but the *Nettie Cushing* apparently changed course and struck the *Metis* hard on her port side. The *Nettie Cushing* was able to make it safely to shore, but the *Metis* was less fortunate. Taking on water, she soon lost power while still miles from land. Four lifeboats were launched, but they were swamped in the rough seas. Many of the passengers and crew were left clinging to the top of the hurricane deck. The deck broke free and started drifting to shore. This engraving vividly imagines the terrible predicament of those passengers on the *Metis* who were stranded on this fragile raft. (RIHS.)

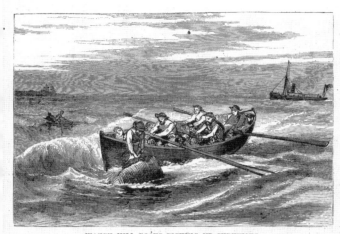

WATCH HILL BOATS PICKING UP SURVIVORS.

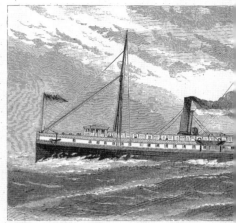

THE "METIS."

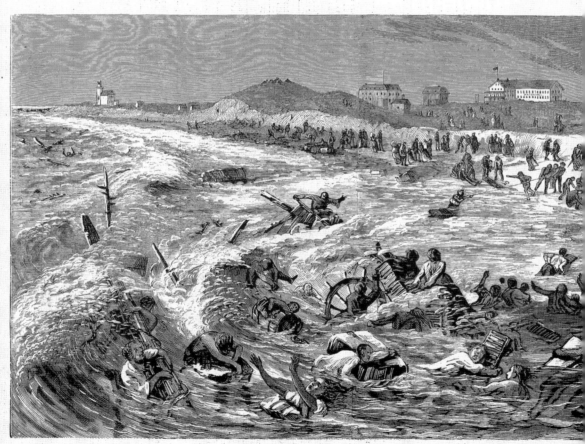

THE WRECK OF THE "METIS"—THROWN UP ON THE BEACH.—Fr

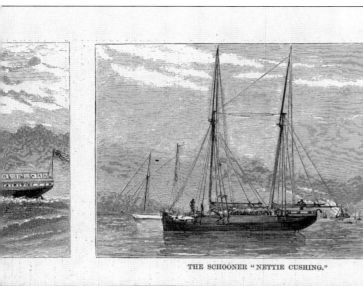

THE SCHOONER "NETTIE CUSHING."

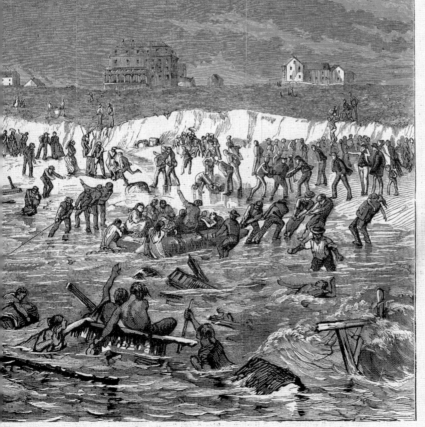

BY THEO. R. DAVIS.—[SEE PAGE 734.]

The *Metis* and the *Nettie Cushing* are pictured in this artist's rendering of the disaster, with bodies and debris washing ashore. This engraving was printed in *Harper's Weekly* on September 21, 1872. (TextBASE Inc.)

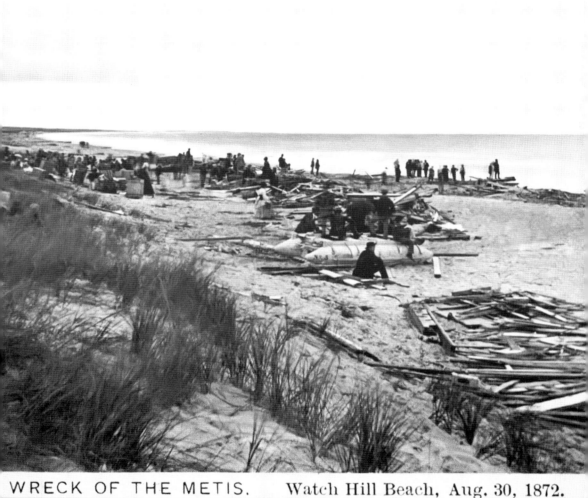

WRECK OF THE METIS. Watch Hill Beach, Aug. 30, 1872.

Though some of the passengers and crew made it to shore alive on the floating deck, and the volunteer crew of the Watch Hill Life-Saving Station and local fishermen braved the rough seas to save 32 more, around 50 perished. Several bodies kept afloat by their *Metis* life preservers were picked up at sea in the next few days while others washed ashore, and the work of identifying the bodies and clearing the beach of debris began. (MS.)

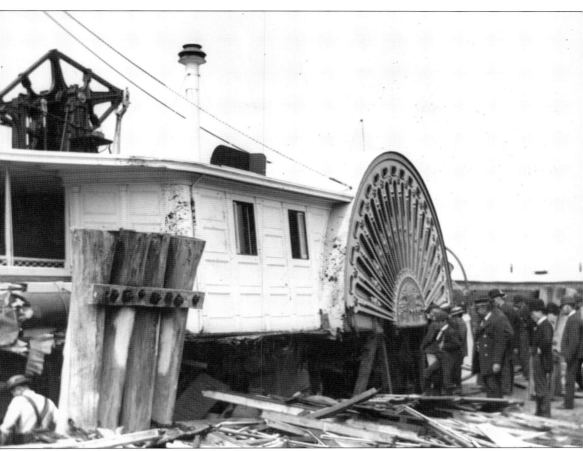

The morning of June 29, 1889, was foggy, and the *Eolus*, a steamship of the Newport and Wickford line, and the *Bay Queen*, of the Continental Providence line, met abruptly just north of Gould Island. There was a terrific crash as their starboard sides smashed into each other, and then each was left alone again in the fog. On board the *Eolus*, there was a rush to launch the two life boats that had survived the collision, but the *Eolus* was in no immediate danger of sinking, and when a band began to play on the deck, the panic was calmed. A local tug heard the distress signals of the steamships and towed them both to Providence, where a small crowd gathered to inspect the damage to the *Eolus*, shown here. (PPL.)

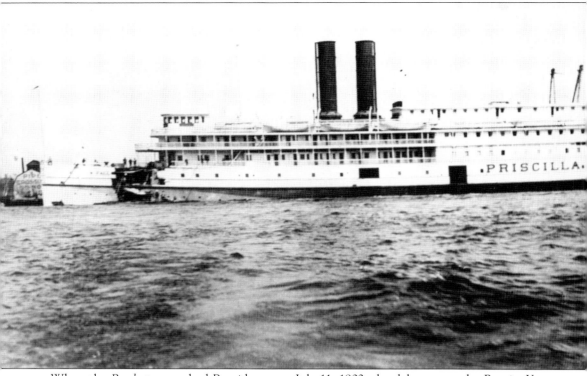

When the *Powhatan* reached Providence on July 11, 1902, the delegates to the Baptist Young People's Union convention in Providence on board sang, "Praise God, from Whom All Blessings Flow." They had reason to be grateful, as their vessel had run into the Fall River steamship *Priscilla* in the fog, and her bow was badly damaged. The *Priscilla* fared worse; her bow was nearly cut off where the *Powhatan* has sliced into it, as shown here. Water broke through the forward bulkhead, sending the front of the steamer down and raising her stern so high out of the water that her rudder became useless. She drifted helplessly out into Rhode Island Sound until she was taken in tow by her sister ship, the *Puritan*. (PPL.)

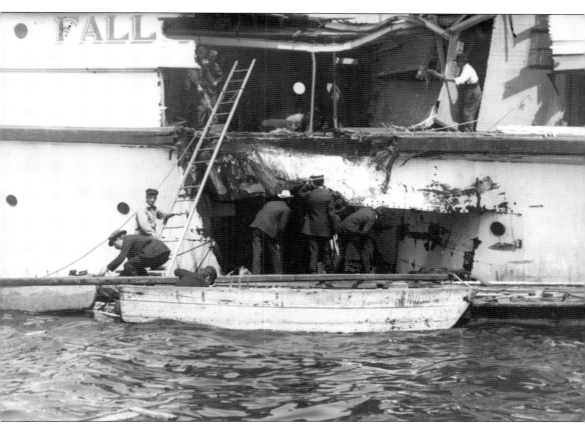

Workers inspect the gaping hole in *Priscilla*'s side. (PPL.)

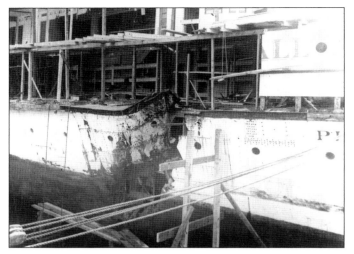

The exact location of the point where the SS *Plymouth* and the SS *City of Taunton* met with a resounding crash on March 19, 1903, is not known. The US Department of Commerce made no effort to pinpoint it in their report on the incident, saying that it occurred "between Gull Island, New York, and Point Judith, RI." The blame for the collision was placed on the thick fog, and both captains were exonerated. (PPL.)

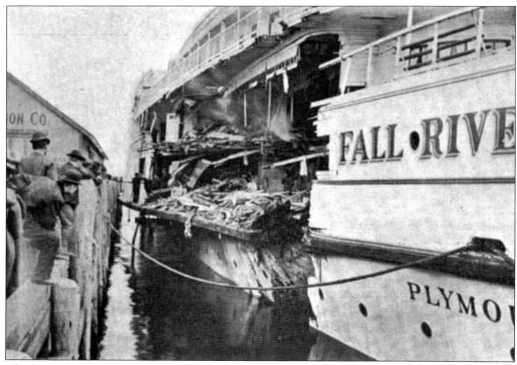

The bow of the *City of Taunton*, a wooden vessel, struck the *Plymouth* on the starboard side, ploughing through her side plating. The *City of Taunton* ripped into the forward cabins used by the crew, opening them to the sea; five of the *Plymouth*'s crew were drowned, and a passenger was killed outright by the collision. (RIHPHC.)

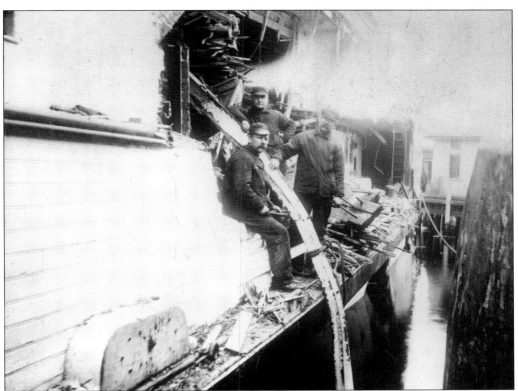

Damage to the *Plymouth* was estimated at $20,000; this image shows repair efforts underway. A large portion of the ship's exterior is missing, and debris is piled on deck. (PPL.)

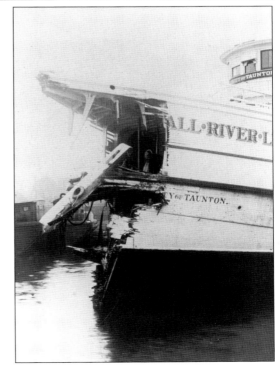

The wooden bow of the *City of Taunton* did not survive the encounter. The *Plymouth* made it to New London on her own, but the *City of Taunton* had to be towed in stern first. (SSHSA.)

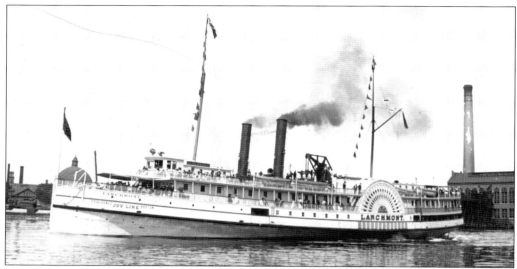

On February 11, 1907, the passenger steamer *Larchmont*, shown here before she became Rhode Island's own *Titanic*, was making the same coastal voyage as the *Metis*, although in the other direction. Off the south shore of Rhode Island, gale force winds were blowing, and the three-masted coal schooner *Harry Knowlton* was blown into the *Larchmont's* path. The *Larchmont* was unable to change course quickly enough to avert disaster; in fact, her hard turn to port made the collision even more inevitable. The *Harry Knowlton* crashed into her port side, cutting through her main steam line and scalding many below decks. When the schooner was tossed away from the *Larchmont*, seawater flooded into the steamship, and she sank rapidly. Lifeboats were launched, but in the frigid cold and confusion, some were only partly filled, and the wind and waves kept them from rescuing others. Many on board the lifeboats were just as unlucky, freezing to death in the 20-foot waves before they reached shore. (PPL.)

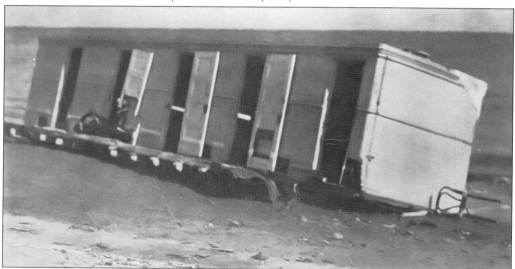

As with the *Metis*, the hurricane deck provided a life raft for some passengers, although it was a horrible experience. Of the 16 who found their way onto the deck, only 5 survived. Each time a large wave crashed over the deck, there would be fewer persons left clinging to it. The survivors were picked up by a passing schooner, and the deck itself washed up on Block Island. (RIHPHC.)

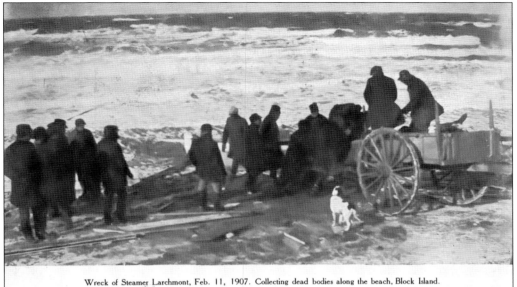

Wreck of Steamer Larchmont, Feb. 11, 1907. Collecting dead bodies along the beach, Block Island. Copyright 1907 by H. Ladd Walford.

Several of the lifeboats with their frozen passengers, only a few of whom survived, came ashore on Block Island along with bodies washed up by the surf. The bodies were collected from the beach in carts, and brought to the New Shoreham and Sandy Point Life-Saving Stations. Approximately 150 of the *Larchmont's* passengers and crew perished in the disaster, with fewer than 20 survivors. (Both, RIHPHC.)

WRECK OF STEAMER LARCHMONT, FEB. 11, 1907. Removing the survivors from the New Shoreham Life Saving Station. Photograph and Copyright 1907 by H. Ladd Walford.

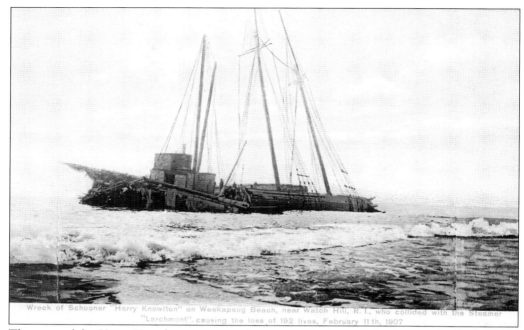

The crew of the *Harry Knowlton* were more fortunate. The bow of the ship was badly damaged from the collision, and she was taking on water fast, so the captain set course for shore. He and the crew had to abandon the ship before it hit land, but they made it to safety. The *Harry Knowlton* eventually ran aground on Weekapaug Beach in Westerly with part of the *Larchmont's* deck and guardrail still fastened to her bow. (RIHPHC.)

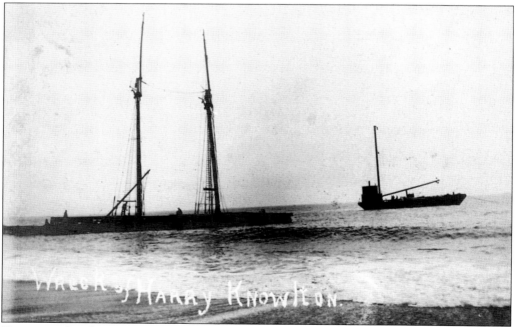

Her cargo of coal was salvaged, but the *Harry Knowlton* herself broke to pieces later that month in heavy winds and surf. (RIHPHC.)

Commonwealth, built in 1908, was nicknamed "the Giantess of the Sound." She was the flagship of the Fall River line until the company disbanded in 1937. On a foggy July morning in 1912, the battleship USS *New Hampshire* was lying in anchor in Newport Harbor when the *Commonwealth* plowed straight into her stern, penetrating about 20 feet. When the vessels separated, it appeared that the *Commonwealth* had sustained little damage, though the *New Hampshire's* steel plates were crushed, its deck torn up, and the captain's cabin demolished. (Right, SSHSA; below, NHHC.)

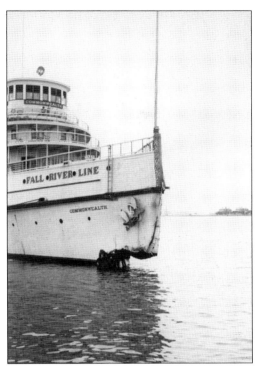

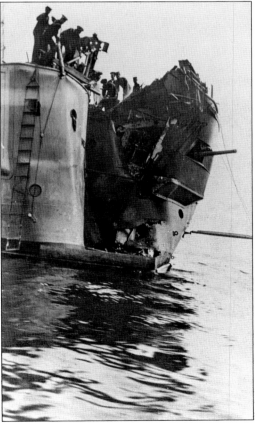

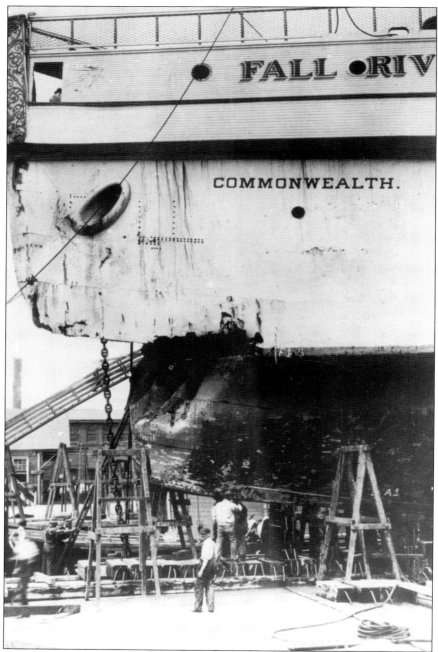

The mangling of the *New Hampshire* did not build public confidence in the Navy's fleet of armored ships, but on closer inspection, it was found that the damage to the *New Hampshire* ended a few inches above the waterline, just above the armor belt, and the portion of the *Commonwealth's* bow that had struck the armor belt was badly crushed. Naval warfare having moved on from cannon shot, it was more important for vessels to be protected below the water. The *New Hampshire*, though looking worse for wear, was actually in much less danger of sinking than its "attacker." Here, the *Commonwealth* is shown waiting for repair work to begin. (SSHSA.)

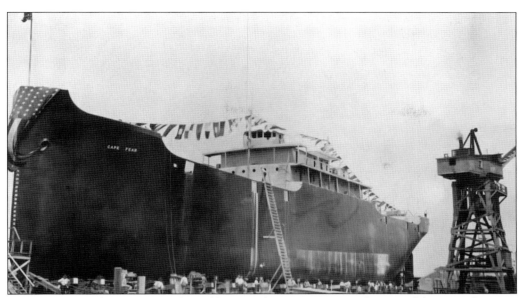

When the United States entered World War I, there was an immediate need for more shipping, and concrete shipbuilding was one of the solutions explored. The *Cape Fear* was one of around 30 concrete steamships built by the Emergency Fleet Corporation, with steel reinforcements placed within forms into which the concrete was poured. The hope was that concrete would reduce damage from collisions, but this was not the case. When the *Cape Fear* collided with her towing tug while her machinery was being installed, a sizable hole was knocked in her concrete hull, foreshadowing what was to come. (MM.)

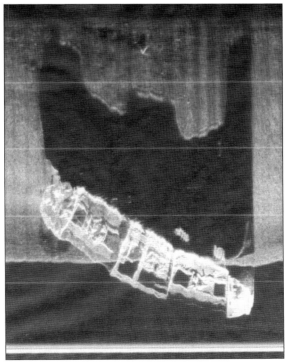

Cape Fear was placed in coastwise service. While leaving Narragansett Bay on October, 29, 1920, she was struck amidships by the heavily loaded steamer *City of Atlanta*. According to one of the survivors, the *Cape Fear* "shattered like a teacup," with chips of concrete flying in all directions. In less than three minutes, she sank in 180 feet of water. Some of *Cape Fear's* crew were pulled aboard the *City of Atlanta* or were able to swim clear, but 19 were pulled down by the suction as the boat sank. The remains of *Cape Fear*, shown in this side-scan sonar image, are still substantially intact (aside, of course, from the damage caused by the collision), lying in deep, cold water in the middle of the East Passage of Narragansett Bay. (Mark Munro.)

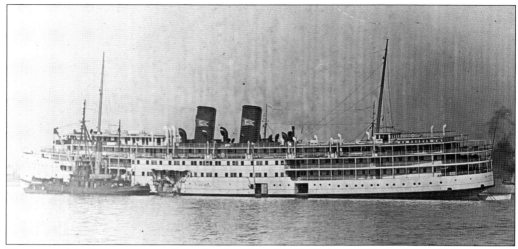

The steamship *Boston* was run down by the oil tanker *Swift Arrow* off the shore of Narragansett in heavy fog on the evening of July 21, 1924. Four individuals—the unfortunate occupants of staterooms 41, 42, and 68—were killed when the bow of the *Swift Arrow* crashed through the side of the ship. The *New York Times* reported that the occupant of a nearby inner cabin woke to find himself looking up at the red bow of the *Swift Arrow*; a minute or two later, the bow slowly withdrew. Finding it too difficult to get dressed in his mangled cabin, the passenger decided to go back to bed. The image below shows a close-up of the damage. (Above, MM; below, Leslie Jones Collection, BPL.)

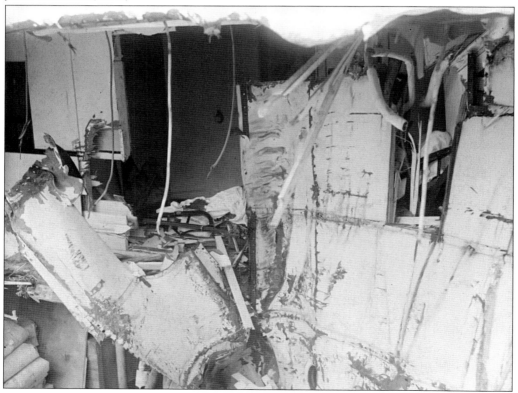

During the several hours it took for the passengers to be evacuated into lifeboats, three young women brought a phonograph up on deck and staged an impromptu dance party to improve moral. The *Swift Arrow* remained on the scene to assist, and three other passenger steamships came to pick up the lifeboat passengers. They had to move with the utmost care lest they run down the small boats in the dark and the fog. The lifeboats were collected after they had done their job. (Leslie Jones Collection, BPL.)

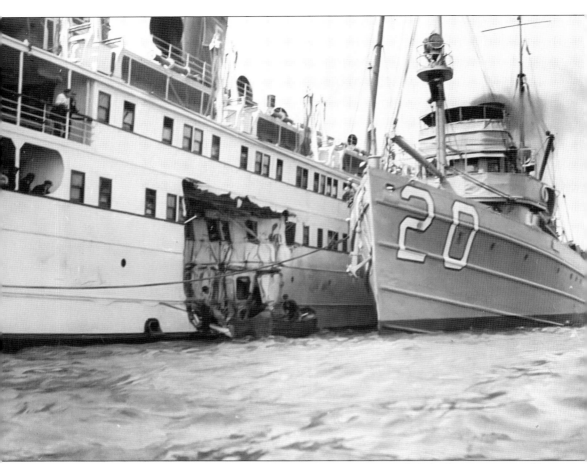

With help from other vessels, including the minesweeper USS *Bobolink*, the *Boston* was able to reach the Boston Navy Yard for repairs. She is shown here in Boston alongside the *Bobolink*; the damage from the collision is clearly visible. (MM.)

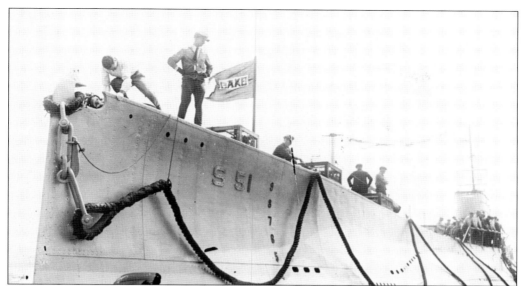

The submarine USS *S-51* (above), launched in 1921, was cruising on the surface off Block Island on the night of September 25, 1925. The crew of the merchant steamer *City of Rome* spotted the *S-51*'s white masthead light but were unsure of the other vessel's course, speed, or intentions, so they altered course away from the unknown light. The crew of the *S-51* spotted the *City of Rome*'s green sidelights and held their course in accordance with the current rules of the road. After altering course, *City of Rome* spotted the submarine's red sidelight, and realizing that they were on a collision course, turned and backed her engines, to no avail. The *City of Rome* slammed into the *S-51*. The result was a tragedy. Only 10 of the 36 men in the submarine escaped, and of these, 7 died in the cold water. Both vessels were found to be at fault—the *City of Rome* for not slowing down and not signaling her change of course, and the *S-51* for having improper lights. The US Navy argued that submarines were exempt from complying with regular laws pertaining to lights, to which the court responded that submarines should then "confine their operation to waters not being traversed by other ships." (Above, NHHC; below, Leslie Jones Collection, BPL.)

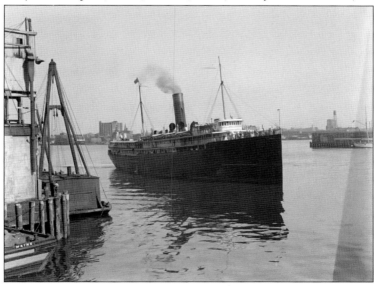

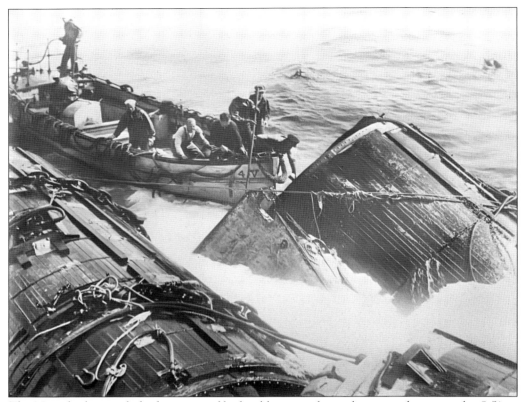

The Navy had recently had a string of bad publicity, and was determined to raise the *S-51* to recover the bodies. Initial efforts immediately following the sinking, when there was still hope that there might be survivors on board, were unsuccessful. The second effort took place from October 1925 to July 1926 and involved Navy divers affixing pontoons to the sunken sub to float it to the surface. (Leslie Jones Collection, BPL.)

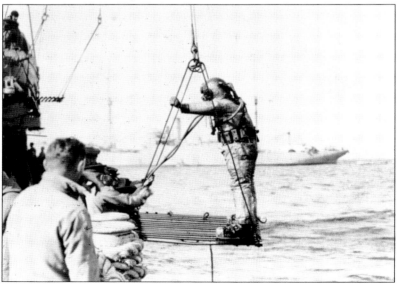

The salvaging of *S-51* involved the Navy's top dive team, who were given the job of attaching the pontoons to the sunken sub. A decompression chamber on board the salvage vessel made the work possible. (NHHC.)

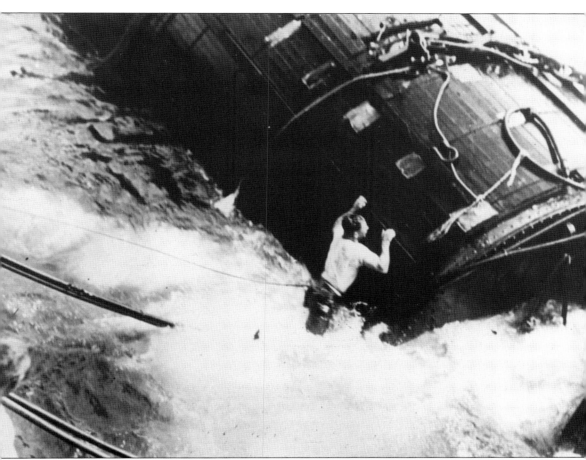

In this image, a salvage worker is trying to close the air valves of the pontoon, which had floated *S-51* too much out of the water, on June 24, 1926. (NHHC.)

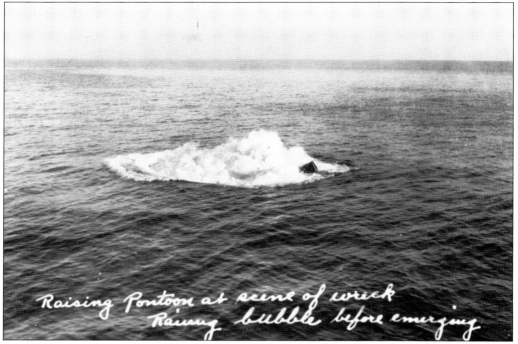

Air bubbling on the surface of the water heralds the successful refloating of *S-51*. (NHHC.)

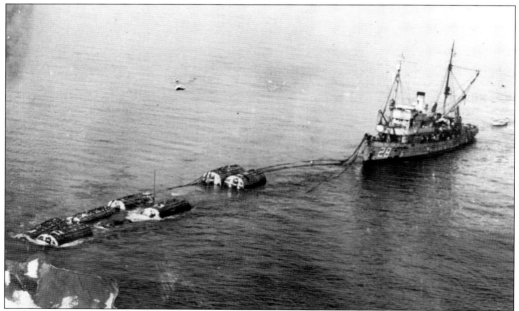

When *S-51* had been raised, it was towed, still supported by pontoons, by USS *Falcon* to the Brooklyn Navy Yard on July 4, 1926. (NHHC.)

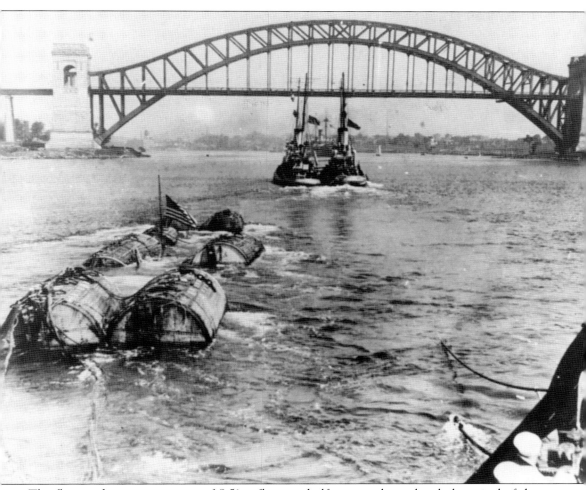

The flag on the conning tower of *S-51* is flying at half-mast at the melancholy arrival of the submarine in New York. (NHHC.)

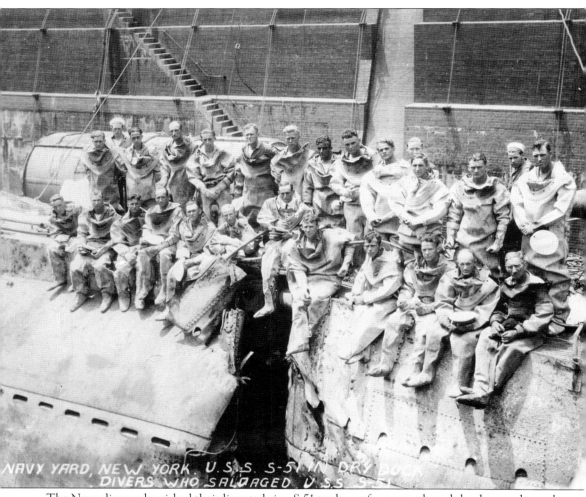

The Navy divers who risked their lives to bring *S-51* to the surface pose aboard the damaged vessel as she sits in the Brooklyn dry dock. The damage to her hull is clearly visible. (NHHC.)

Four

FIRES AND EXPLOSIONS

In 1872, the *Abbie Dunn* was destroyed by her cargo of lime, which she was bringing to Newport. When she sprang a leak in a storm just before reaching her destination, the wet lime combusted. She was beached in the shallows off King's Park and left to decay. Part of her structure was still visible in the early 20th century. (PPL.)

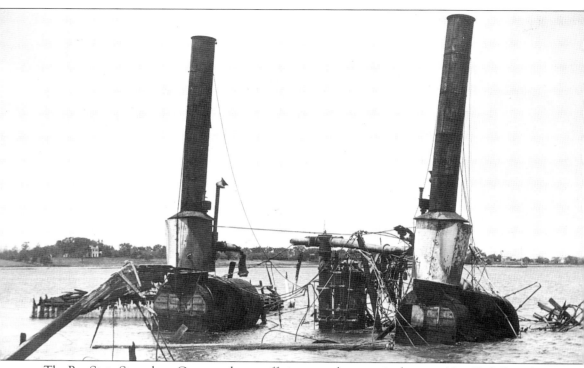

The Bay State Steamboat Company began offering steamboat service between New York City along the coast and up Narragansett Bay to Fall River, Massachusetts, in 1847, and other companies, like the Fall River Line, soon followed suit. With the development of steam power came the risk of fires and explosions, and the history of passenger steamships in Rhode Island waters includes several such disasters. One of the first to catch fire was the *Empire State*, launched in 1848, the third passenger vessel in the Bay State Steamboat Company fleet. She was destroyed by fire on May 14, 1887, at her winter mooring in Bristol. The cause of the fire is unknown, but it engulfed her with such ferocity that one of the caretakers on board was scorched during his escape. She sank in the harbor, with only her smokestacks, walking beam, and flagstaffs visible above water. (RIHPHC.)

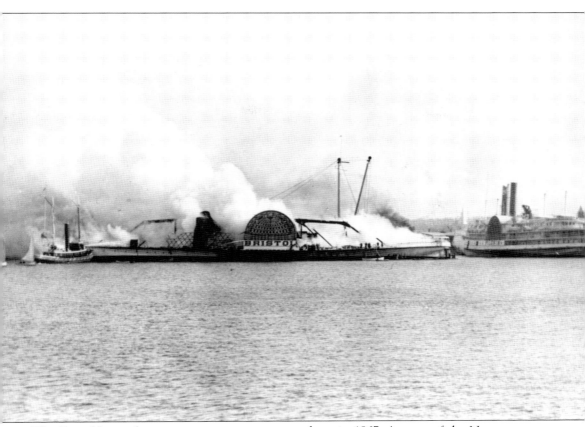

The *Bristol* began her career as a passenger steamboat in 1867. As part of the Narragansett Steamship Company fleet and then part of the Fall River Line during the next 21 years, the *Bristol* had a somewhat checkered safety record, sinking two other vessels in collisions; she herself ran ashore several times but was refloated. On December 29, 1888, the *Bristol* left New York on what was to be her final voyage. She arrived at Newport in the early morning of December 30, and her crew began to cook breakfast. Unfortunately, a saucepan of fat caught fire, and by 6:00 a.m., flames were spotted breaking through the ship's upper deck. (PPL.)

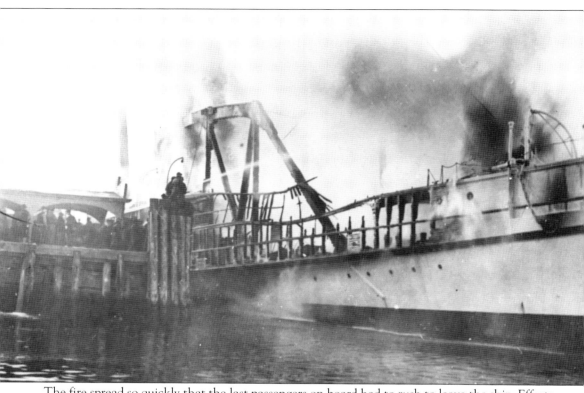

The fire spread so quickly that the last passengers on board had to rush to leave the ship. Efforts to extinguish the flames from the shore were unsuccessful. (PPL.)

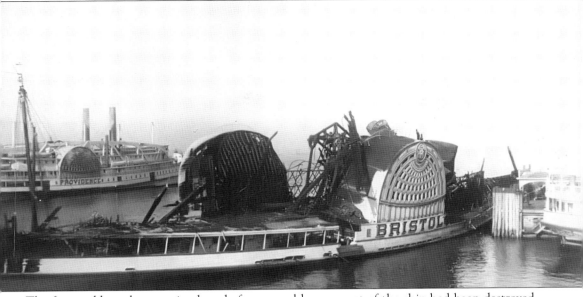

The fire could not be contained, and after several hours, most of the ship had been destroyed and subsequently sank. The remains of the *Bristol* were raised the following month and sold for salvage. (PPL.)

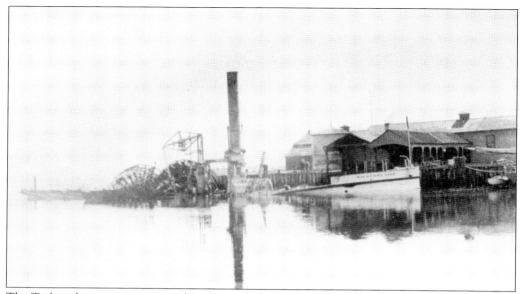

The *Tockwogh*, a passenger steamship that travelled between Providence and Wickford, burned to the water's edge at the dock in Wickford early in the morning of April 11, 1893. Only four years old, the vessel was a total loss, giving it the dubious distinction of having had the shortest career of any Rhode Island steamship. (SSHSA.)

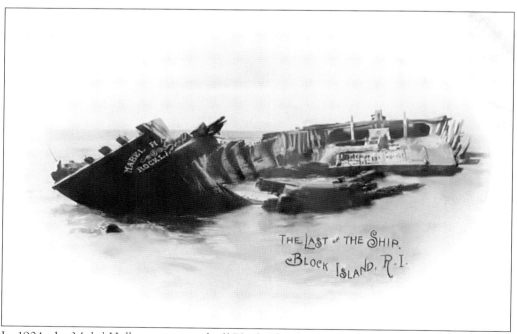

In 1904, the *Mabel Hall* went aground off Block Island with a cargo of lime. When the water reached her cargo, it combusted, and the ship was destroyed by the fire. Her remains later washed up on the beach, her name still there to identify her. (PPL.)

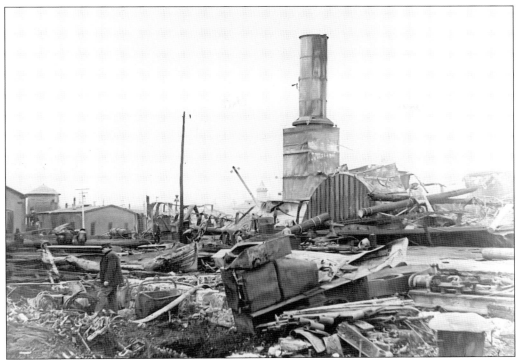

The SS *Plymouth* was a Fall River Line passenger vessel commissioned in 1890. In 1906, a fire at the Newport Dock tore through her and left only the stack and wheel still standing. (PPL.)

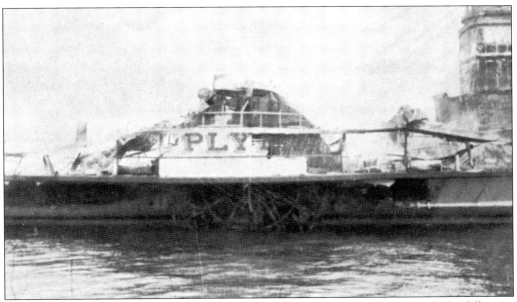

Though almost all her superstructure had been burned away, *Plymouth* was rebuilt the following year and continued to carry passengers until the Fall River Line folded in 1937. The *Plymouth*, along with her sister ships *Priscilla*, *Providence*, and *Commonwealth*, were then towed to Baltimore and scrapped. (Norman J. Brouwer.)

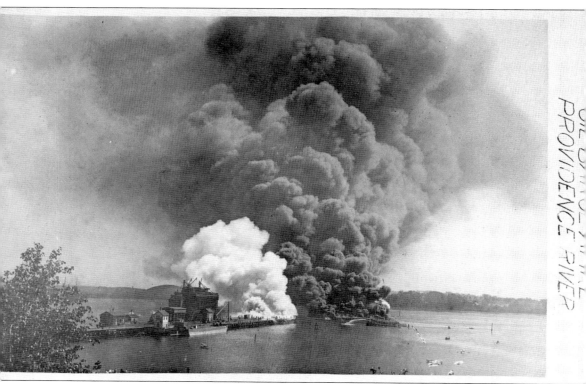

On July 10, 1909, the Texas Oil Company's barge *Harrison*, with 135,000 gallons of oil on board, caught fire in the Providence River. A quarter of a square mile of Providence Harbor was covered with flames. As the burning barge started drifting, every available tug was mobilized to pull other vessels out of the danger zone, but the three-masted barge *Helen A. Wyman* was badly scorched before it could be pulled to safety. The *Harrison* burned for 18 hours until the fire consumed all the oil on board. (PPL.)

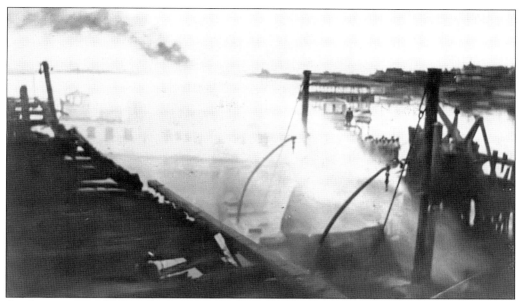

On the morning of September 20, 1914, the ferry *Conanicut*, which ran from Jamestown to North Kingstown, caught fire. (JHS.)

The *Conanicut* was deliberately sunk to save the hull and the engine. After this had extinguished the flames, bilge pumps were brought aboard, and she was raised and refloated. (PPL.)

The fire had caused considerable damage to her superstructure. This was repaired and she continued in service until the Jamestown ferryboats were made redundant by the construction of the Jamestown Bridge in 1940. (Both, JHS.)

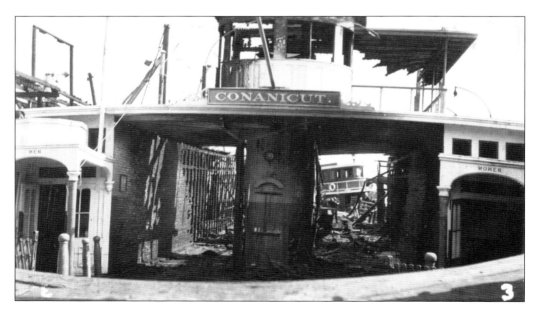

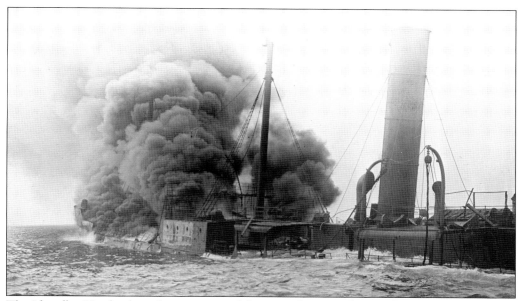

The *Llewellyn Howland* incident was one of the more dramatic shipwreck fires in Rhode Island history, but the fire was a secondary occurrence in its story of misfortune. The *Llewellyn Howland* went aground on April 21, 1924, off Brenton's Point, Newport, and stuck fast on the rocks of Seal Ledge. The weather was not to blame; rather, the stranding was due to pilot error or a misplaced buoy. There was no loss of life, and this would have been a minor wreck had it not been for the fact that the cargo was 26,000 barrels of fuel oil. One of the two oil tanks ruptured almost immediately, and it was determined that the other could not be pumped out. The vessel could not be towed out to sea in any timely fashion. To avoid an environmental catastrophe to the beaches and fisheries of Newport, the decision was made to set the oil alight. (Newport Historical Society.)

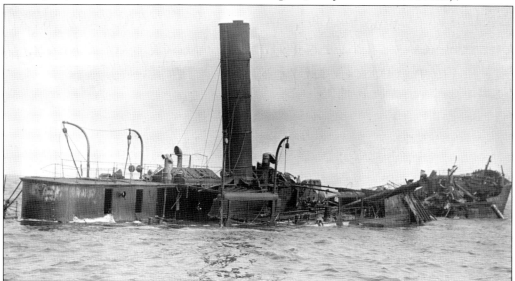

After the fire, about 500 gallons of oil remained on board, but judicious application of two 300-pound charges of TNT took care of that problem and left the smokestack of the *Llewellyn Howland* rising above the wreckage. (Newport Historical Society.)

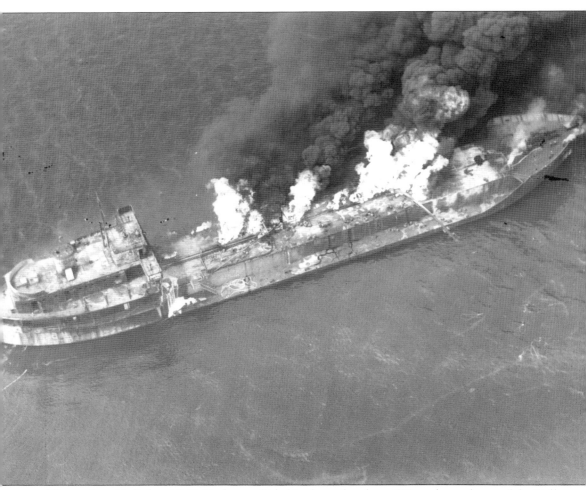

The tankers *Gulfoil* and *S.E. Graham* collided in dense fog about 500 yards northeast of the Bull Point Lighted Bell Buoy in the east passage of Narragansett Bay on August 7, 1958. An almost instantaneous fire engulfed both vessels. The *Graham*, burning fiercely, drifted with the tide up Narragansett Bay until she was grounded by vessels of the US Navy and the Coast Guard on the north end of Rose Island. The *Gulfoil* grounded on Newport Neck off Fort Adams, where it burned just as fiercely. (JHS.)

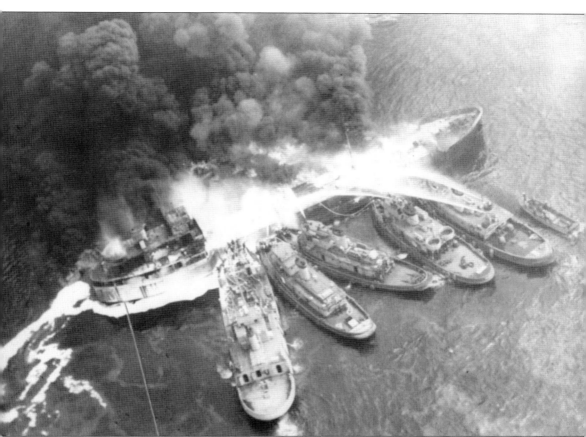

Six fire boats rushed to the scene to extinguish the flames. It took almost a day to extinguish the fire. (RIHPHC.)

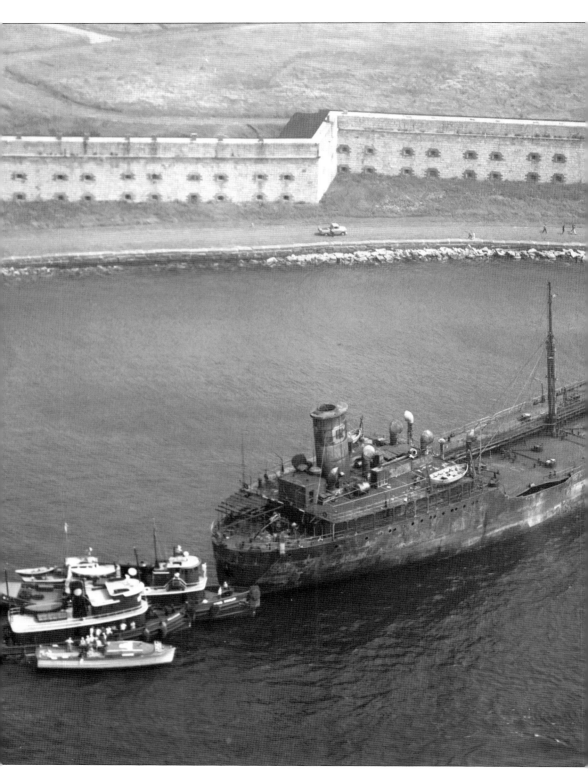

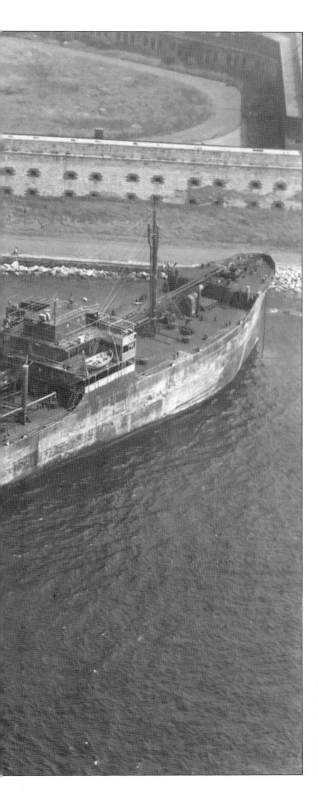

When the fire was out, the *Gulfoil* was a charred hulk, damaged not only by the flames, but also by the collision. Nine bodies were found on board, and eight more were recovered from the water. (Newport Historical Society; photograph by John Hopf.)

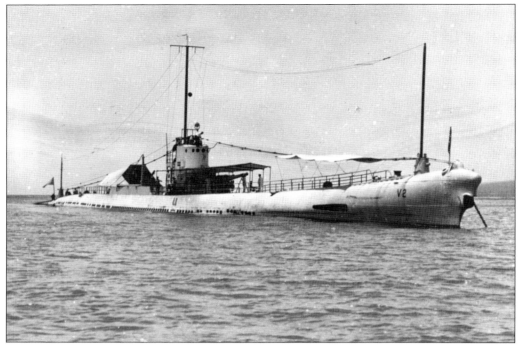

The submarine USS *Bass* was launched under the name *V-2* in December 1924. Her last service to the Navy was to serve as a target for the test of an acoustic homing torpedo, the Mark 24 Fido mine, off of Block Island on March 12, 1945. The explosion of the torpedo is shown below. (Both, NHHC.)

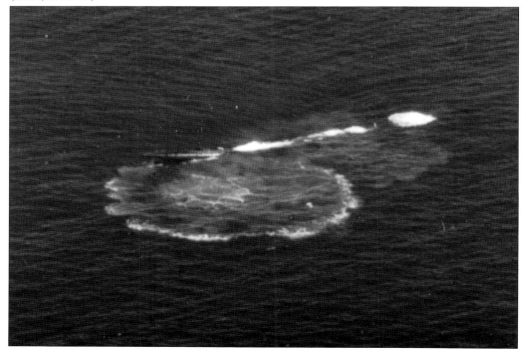

Five

STORMS AND GREAT GALES

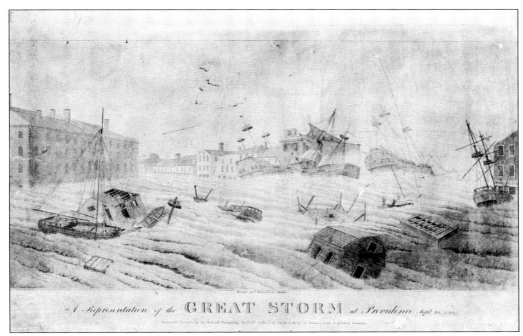

Storms and great gales have historically swept through Rhode Island's waters on a regular basis, sinking vessels at sea and tossing them onto shore. This earliest image of such a storm, the Great Gale of 1815, shows ships cast loose from their moorings and being swept through the flooded streets of Providence. (LOC.)

In 1856, *LV-11*, a 104-foot-long schooner-rigged vessel, was assigned to the dangerous reefs off the shore of Newport as a lightship equipped with two lanterns and a bell for fog warnings. On Friday, October 20, 1865, a powerful gale slammed the coast. *LV-11* broke away from her moorings and was stranded on Price's Neck. She was refloated, towed to Newport for repairs, and returned to her station, where she remained until 1887. When she was retired in 1925, she was thought to be the oldest vessel in the US Lighthouse Service. (NA.)

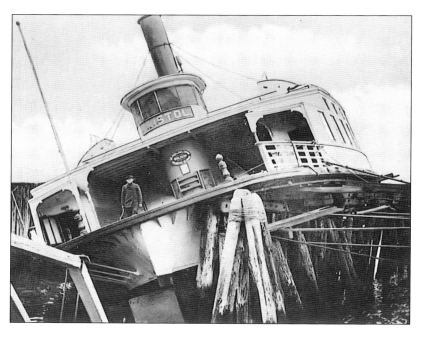

In October 1907, a fierce gale smashed the side-wheel steamer ferry *Bristol* against her landing in Bristol. At the next high tide after the storm died down, she was partially released, and was afloat again the next day. The damage was relatively minor. Only a few braces and some of the deck planking were damaged, and she was soon repaired and returned to service. (RIHPHC.)

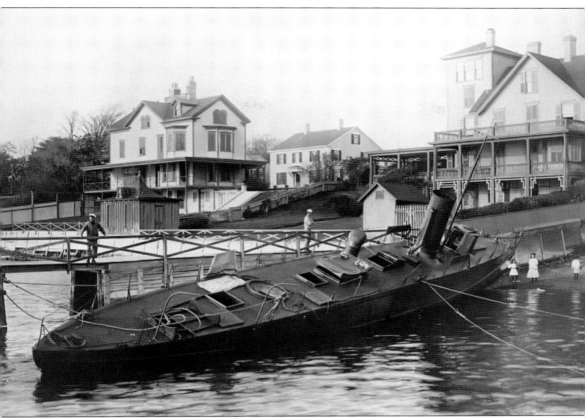

The USS *Stiletto* was launched in 1885 in Bristol and purchased for the US Navy in 1887. She was adapted for use as a torpedo boat and was the first Naval vessel capable of launching self-propelled torpedoes. Hurricane force winds in September 1896 swept *Stiletto* and her sister ship, the *Cushing*, which had come to her aid, onto the shore. *Stiletto* was pushed ashore just north of the government pier. Though initial efforts to pull her off were unsuccessful due to the falling tide, eventually, she was got off. (NWCM.)

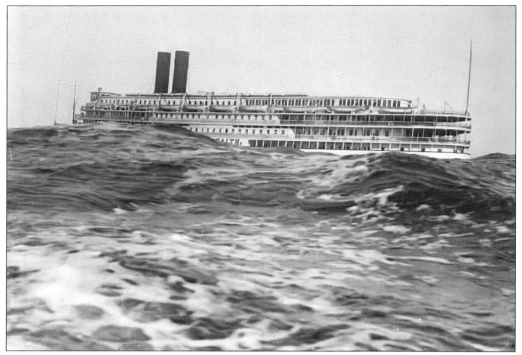

In October 1925, the steamship *Commonwealth* was caught in a storm off Narragansett, and its paddlewheel was badly damaged. (Leslie Jones Collection, BPL.)

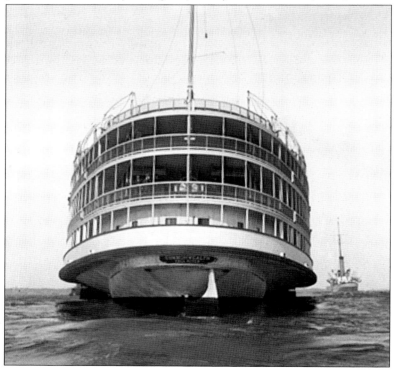

The *Commonwealth* was towed to Newport for repairs, her massive size dwarfing the tug pulling her (she was called "the Giantess of the Sound" for a reason). (Leslie Jones Collection, BPL.)

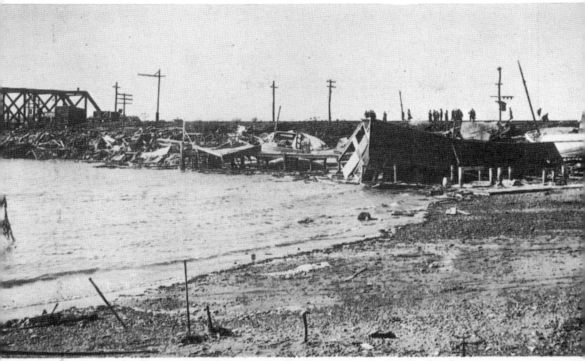

THE GREAT NEW ENGLAND HURRICANE OF 1938

On September 21, 1938, a storm of phenomenal strength swept up Narragansett Bay with an unprecedented storm surge. With no warning, the oceanfront communities were caught unprepared, and this hurricane remains one of the worst disasters ever to befall Rhode Island. Hundreds of small craft were thrown about by the wind and the wall of water that swept up Narragansett Bay. Boats piled up wherever the water met any opposition, such as at Tiverton's Railroad Bridge. (RIHPHC.)

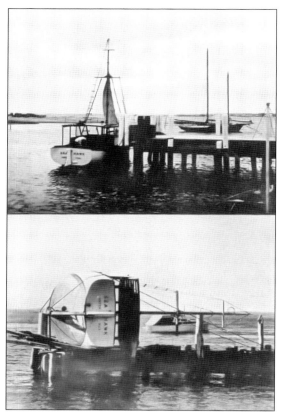

The before and after shot of the *Sea Hawk* in Westerly (at left) and an image of an unidentified vessel in Tiverton (below) show how the storm redeposited boats at odd angles. (Both, RIHPHC.)

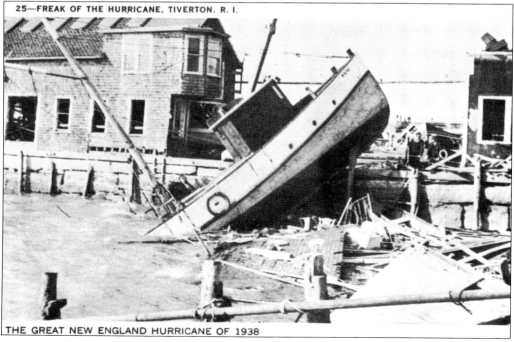

25—FREAK OF THE HURRICANE, TIVERTON, R. I.

THE GREAT NEW ENGLAND HURRICANE OF 1938

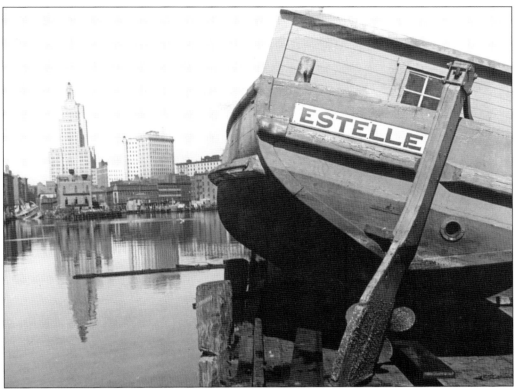

The storm surge swept up to Providence, flooding the city. The *Estelle* was left perched on a dock, with downtown Providence in the background. (RIHPHC.)

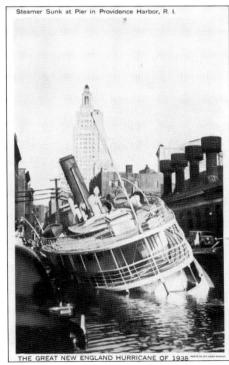

The steamship *Monhegan* was swamped at Dyer Street Wharf in Providence. She was towed to Prudence Island and left to disintegrate off Sandy Point. (RIHPHC.)

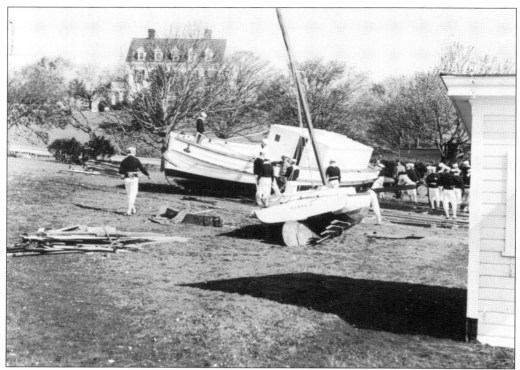

Cleanup after the hurricane was a long and costly job, as the coast was littered with debris. Small craft and other debris were washed up onto the lawns of Naval Station Newport. (Both, NWCA.)

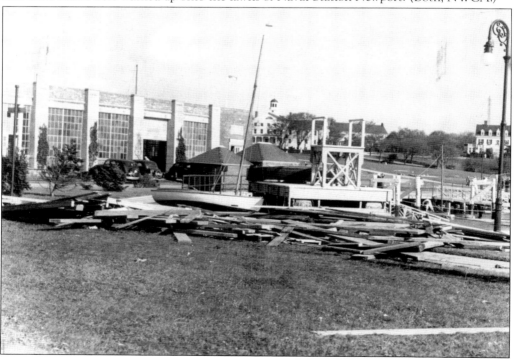

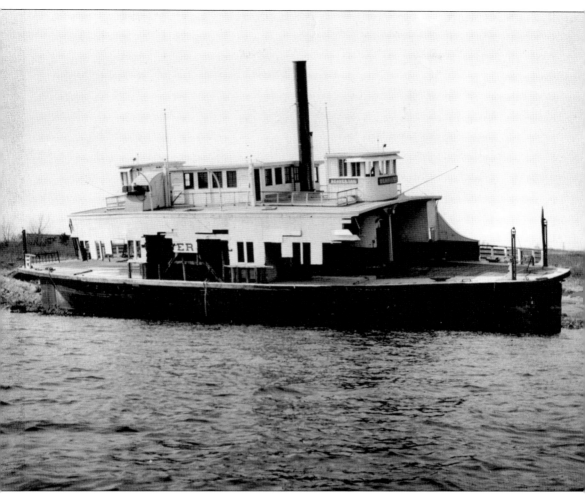

Not only was there great damage to private vessels, but also to the island communities of Narragansett Bay that depended on ferry service to reach the mainland and were cut off from shore. The ferry fleet of Jamestown, for instance, was hit hard. The ferry *Beaver Tail* was driven ashore at the north end of the island, and much of her superstructure was badly damaged or washed away. (JHS.)

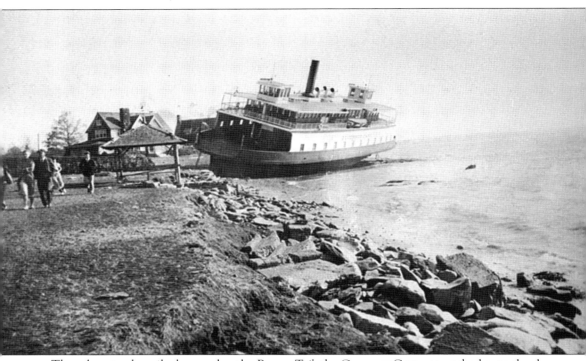

Though not as heavily damaged as the *Beaver Tail*, the *Governor Carr* was washed onto the shore north of the harbor. (JHS.)

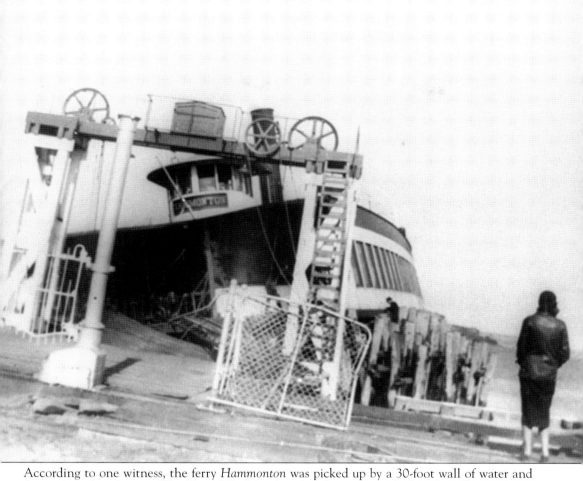

According to one witness, the ferry *Hammonton* was picked up by a 30-foot wall of water and dumped on the pilings at West Ferry. The Monday after the storm, with their ferry fleet in ruins, Jamestown residents voted 240-23 to approve a bridge to the mainland. (JHS.)

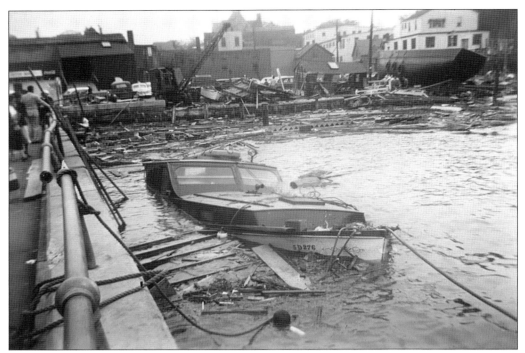

Hurricane Carol in 1954 produced fewer dramatic images of ships ashore, but likewise capsized small craft and washed others inland. This motorboat was swamped at Long Wharf, Newport. (Newport Historical Society.)

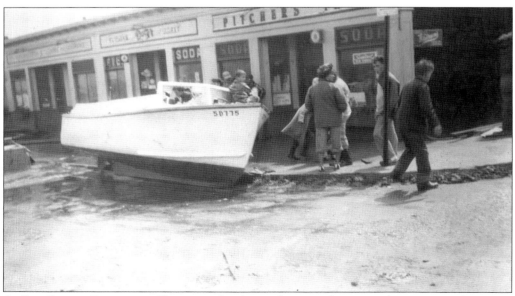

At East Ferry in Jamestown, Hurricane Carol sent this motorboat on a shopping trip. (JHS.)

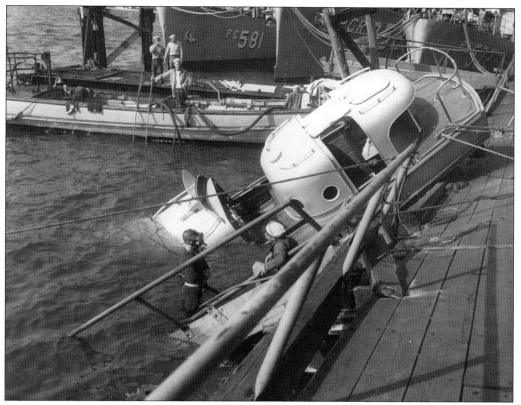

Hurricane Carol was no respecter of rank; here, the launch used by the admiral of Naval Station Newport is shown battered against its dock. (NWCA.)

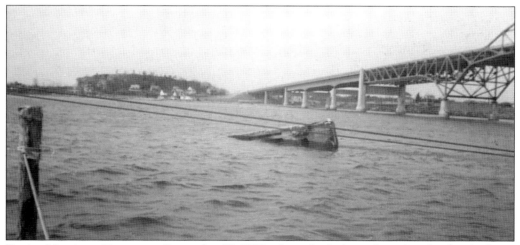

During Hurricane Donna, on September 12, 1960, a barge broke loose from the wharf at Anthony Point and went aground 700 yards from the Spire in Tiverton. The residents of Tiverton did not think it added value to their water view and petitioned the Army Corps to remove it later that fall. (RIHPHC.)

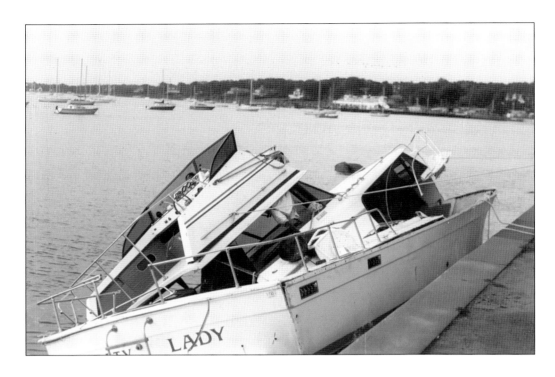

Hurricane Gloria of 1985 was a much less costly storm than her predecessors, but she too tossed around small vessels. The powerboat *Crafty Lady* and an unidentified sailboat were washed up at the seawall at East Ferry, Jamestown. (Both, JHS.)

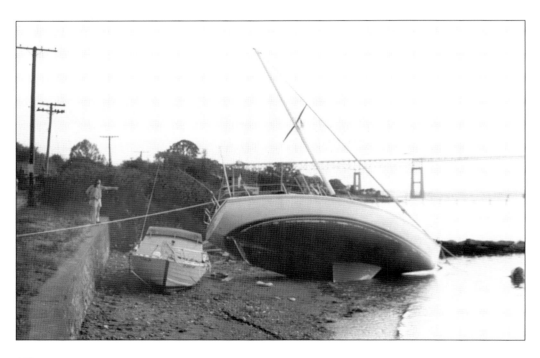

Six

DERELICT AND ABANDONED

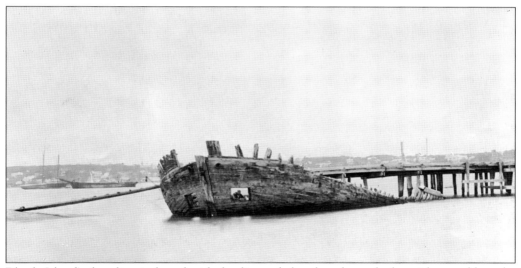

Rhode Island's shoreline is dotted with derelict and abandoned vessels that either could not be salvaged at the time of wrecking or would have cost more to repair than they were worth. Some ships that wrecked offshore broke apart and washed onto the rocks and beaches, while others were left to rot and break apart just as they were, like this unidentified vessel at a dock in Westerly. Many derelict wrecks were hazards to navigation or considered eyesores, but a picturesque shipwreck on the beach could be an asset for tourism—the *Stonington Mirror* in December 1886 noted that "should the brig and three masted schooner now ashore at Watch Hill hold together until the beginning of next season they would prove a great attraction to the city people." It is not clear whether this Watch Hill derelict was an attraction or not. (WPL.)

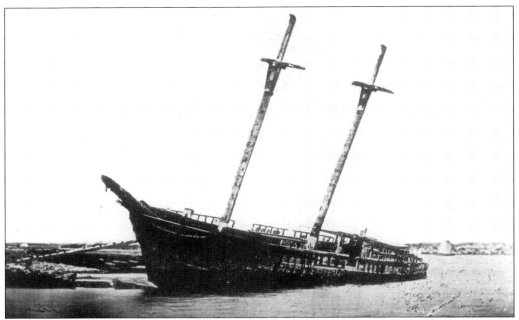

Often, old ships no longer worth maintaining were deliberately run aground in out-of-the-way coves and left there as a cheap and easy disposal method. Brenton Cove in Newport is home to several such vessels abandoned in the 19th century. The oldest derelict vessel in Brenton Cove, the *Gem*, was shipwrecked off Block Island in the 1850s and then towed to Newport to be rebuilt. She ended up abandoned and was identified by a 19th-century abolitionist as a slave ship, although there is no evidence that supports she ever was one. The ship shown in this photograph published in 1873 is possibly the *Gem*. It appears to be located off the sandy beach of Fort Adams Park, where the Rhode Island Marine Archaeology Project located some remnants of a wooden vessel in the 1990s. (RIHPHC.)

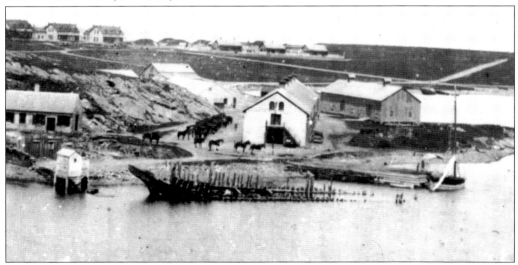

There are those who believe that the *Gem* is actually another derelict vessel located by the Fort Adams Park boat ramp next to the old mule barn, shown here in a photograph from 1891. Though some of this ship still survives, there is not enough left to identify her. (PPL.)

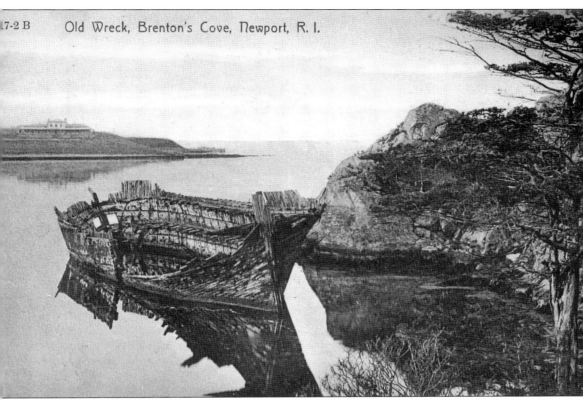

On August 10, 1872, the *Bessie Rogers* was lying at anchor in Newport Harbor in a thick fog when it was rammed by the steamer *Bristol*. The *Bristol* was run ashore on Coal Mine Flats to keep her from sinking and was later refloated. The *Bessie Rogers* sank but was raised and deliberately grounded off the mansion of Edwin D. Morgan at Beacon Rock in Brenton Cove, across from Fort Adams. (RIHPHC.)

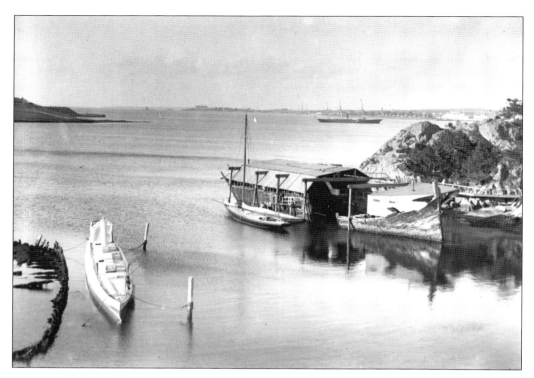

The Morgan family used the *Bessie Rogers* first as a houseboat and then as a floating swimming pool and bathhouse. She was badly damaged by a storm in 1914 and, after that, was left to decay. At some point in the early 20th century, a pier was built on top of her, with several pilings driven directly through her remains, as shown above (on the right side of the dock). A second derelict vessel lies further offshore. The image below shows more clearly how close the unidentified wreck actually is to the Morgans' dock. (Above, PPL; below, Newport Historical Society.)

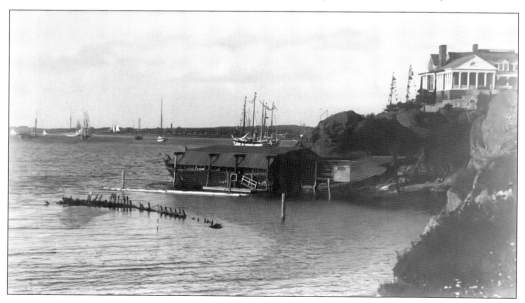

Although Morgan eventually repurposed one derelict vessel for his own use, he was not at first pleased by the two ships rotting off his property. In 1889, two years before the mansion was completed, his contractor wrote to the Navy on his behalf, stating his hope that it could "blow these wrecks to pieces" by hauling them off to be used for torpedo practice (a common fate of old vessels in late-19th-century Narragansett Bay, which was the torpedo testing ground of the US Navy). The Navy did apparently try to refloat at least one of the vessels to use as a target, but it was too decayed to be moveable. (NWCA.)

The unidentified wreck disappears from images of the Morgan estate by the 1920s, although the *Bessie Rogers*, worked into the dock, is still above water. (RIHPHC.)

WILLIAM J. UNDERWOOD,
32 FRANKLIN STREET.

Newport, R. I., *July 1* 1889.

Commander Goodrich.
U. S. Torpedo Station.
Dear Sir,
There are two old hulks lying upon the shore of Mr. E. D. Morgan's place at Brenton Cove, which he is very desirous of having removed.
Would it be possible to make any arrangements whereby you could, in your torpedo experiments, blow these wrecks to pieces?
If any arrangement could be made, will you kindly let me know, and oblige.
Respectfully yours,
Wm J. Underwood.

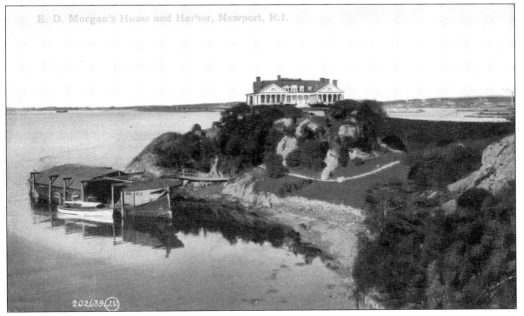

E. D. Morgan's House and Harbor, Newport, R.I.

202639 (J.V.)

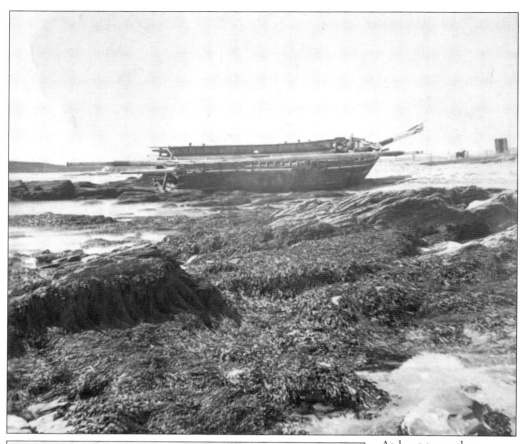

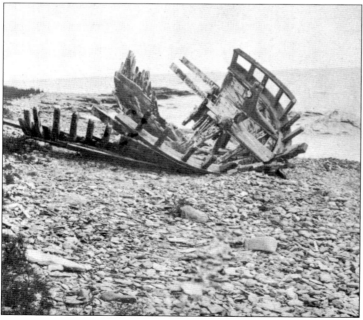

At least two other derelict shipwrecks decorated the shores of Newport and were photographed in 1875. Above is a hulk of a vessel off the estate of Seth Bateman, and at right are the remains of a second vessel near Pirate's Cave; both locations are on the western shore of Brenton Point. (Both, NYPL.)

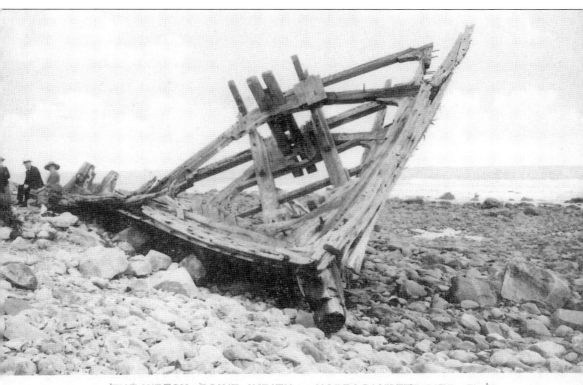

THE WRECK, POINT JUDITH. NARRAGANSETT PIER, R. I.

The schooner *Harry A. Barry* was shipwrecked near Point Judith in February 1887. Salvors worked hard to bring off her cargo and fittings in a race against the stormy seas that were rapidly breaking the ship to bits. What could be salvaged was sold at auction, and what was left of the schooner washed ashore and was left to decay. (RIHPHC.)

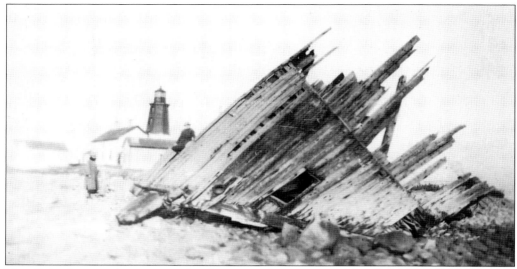

Not all derelict vessels were considered eyesores. Some pieces of wrecked ships were picturesque enough to draw people to the shores to see them and be photographed with them. One particularly appealing piece of wreckage was this prow of an unidentified vessel ornamenting the shore near the Point Judith lighthouse, visible in the background. (RIHPHC.)

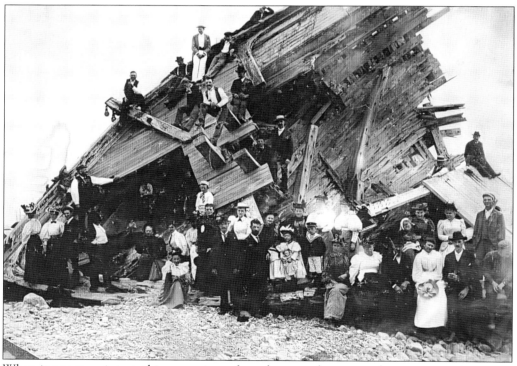

When it was more intact, this same piece of wreckage was large enough to accommodate many visitors at once. (Sallie Latimer.)

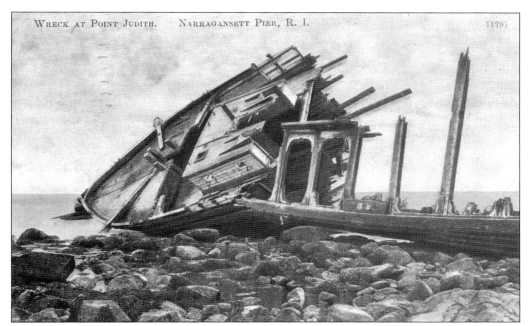

After becoming the subject of many photographs and postcards, such as the one shown above, the wreckage was gradually washed away as storms took their toll. It had been considerably battered by the time the photograph below was taken, and nothing of it is visible today. (Above, RIHPHC; below, LOC.)

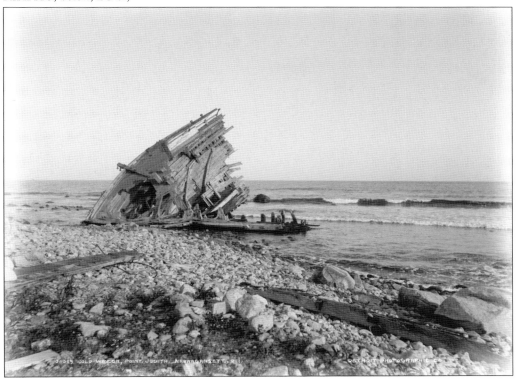

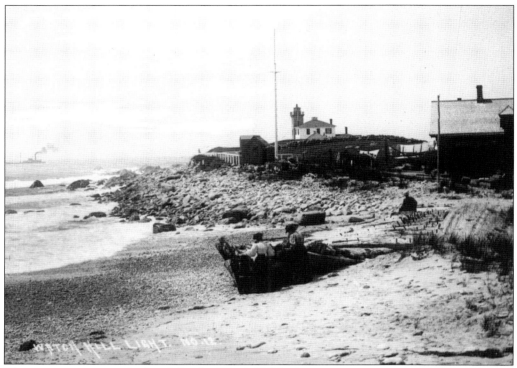

These women visiting the beach by the Watch Hill Light seem very interested in the remains of an unidentified ship. (WHS.)

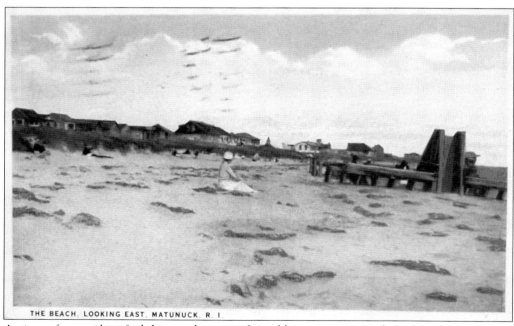

THE BEACH, LOOKING EAST, MATUNUCK, R. I.

A piece of an unidentified shipwreck was used to add interest to an early-20th-century painting of the beach at Matunuck, South Kingstown. (George Hale Library.)

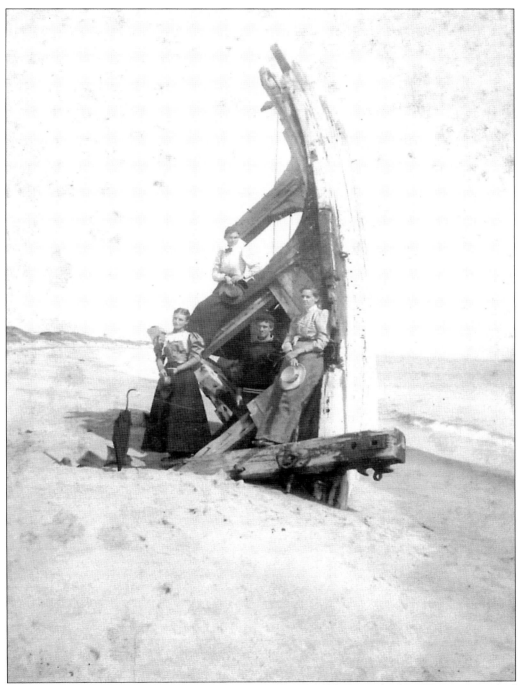

This is another very picturesque piece of shipwreck—possibly from the brig *Toronto*, wrecked in a storm in 1886, or the remains of the *Fred A. Carle*, wrecked in 1885—located on the East Beach at Westerly. Many beachgoers in the 19th century used it as an attractive backdrop for their family photographs, as these members of the Greene and Arnold families did around 1893. (Hope Greene Andrews.)

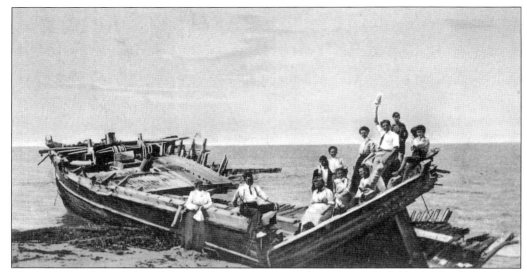

The remains of the ill-fated *Mabel*, which went aground and burned off Block Island, became a pleasant gathering place on the beach. (RIHPHC.)

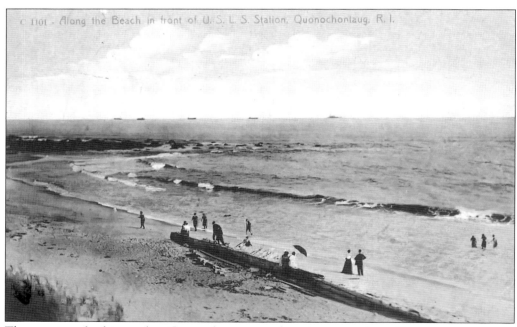

The remains of a shipwreck at Quonochontaug are less picturesque but still serve a purpose as a bench for some of these beachgoers. (RIHPHC.)

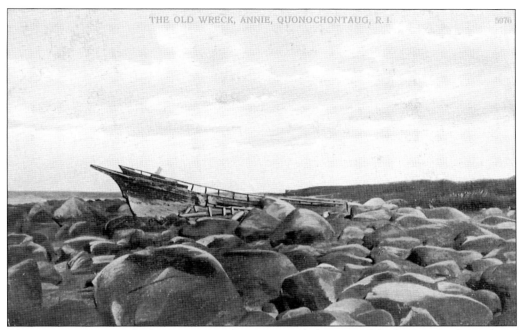

The *Annie A. Kruse*, which went aground in 1889, ended up tossed high up onto the rocks of the beach. (RIHPHC.)

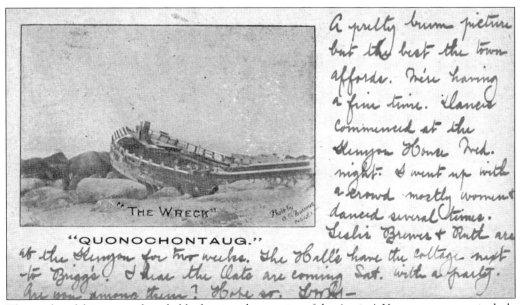

The sender of this postcard, probably showing the remains of the *Annie A Kruse*, was not particularly impressed, calling it "a pretty grim picture but the best the town affords." (RIHPHC.)

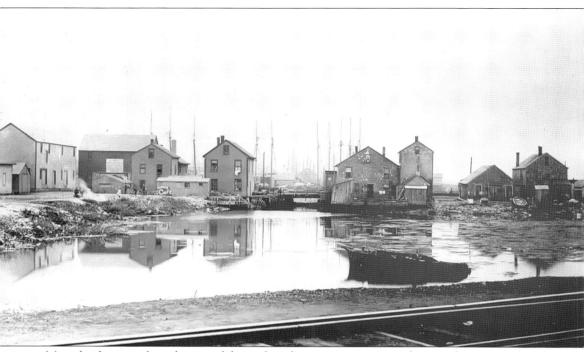

Most derelict vessels and piece of ships, though, were not attractive but simply unwanted trash. The cove at Long Wharf, Newport, was gradually filled in during the 1800s. Included in the fill was a wooden vessel that had been abandoned there at an unknown date. (MS.)

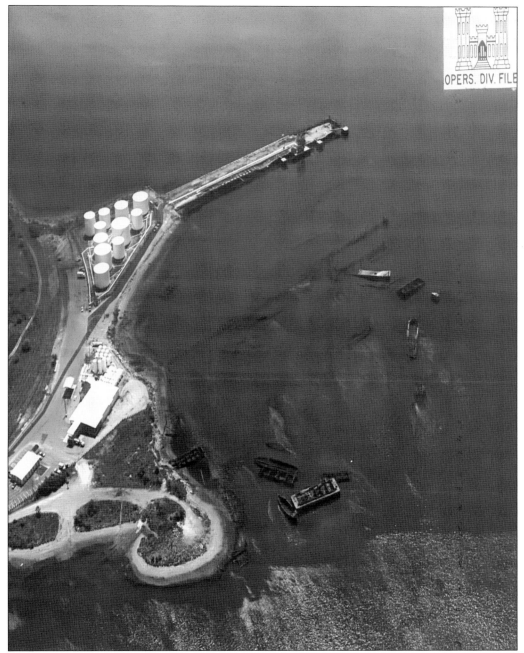

The largest collection of derelict and abandoned vessels in Rhode Island is located on Green Jacket Shoal, off of Bold Point, in East Providence. At least 26 wrecks, mainly from the first three decades of the 20th century, lie in the shallow waters of the shoal alongside a late-19th-century dry dock. The wrecks are so intact and the water so shallow that they can be seen in aerial photographs, like this one from 1975. Two parallel rows of pilings mark the location of the dry dock, and a scattering of the shipwrecks can be seen below it. (USACOE.)

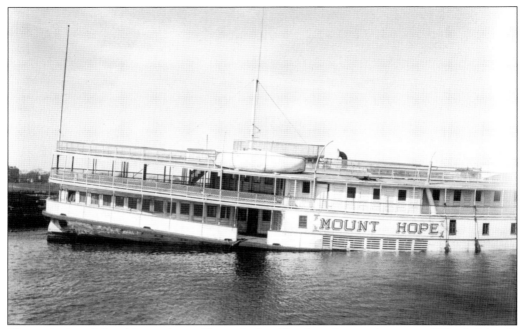

The majority of the shipwrecks on Green Jacket Shoal are barges, but two of Rhode Island's best-known paddle wheel steamships—the *Mount Hope* and the *Bay Queen*—were abandoned here, still substantially intact. No great effort was made to break down the structure of these two steamships. The *Mount Hope*, for instance, was simply left to lie partially submerged off the East Providence shoreline in 1937. (PPL.)

This 1937 photograph, taken from on board the *Mount Hope*, shows the old dry dock and other abandoned vessels in the background. (PPL.)

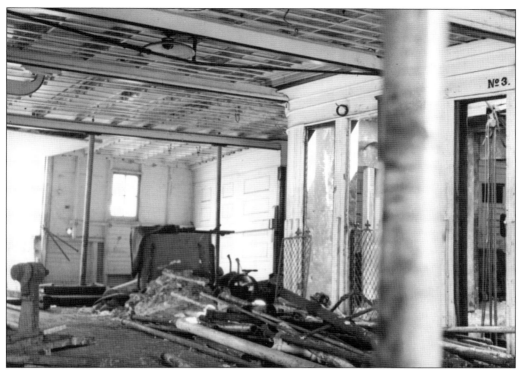

Although the larger structural elements of the ship were not salvaged, the interior of the *Mount Hope* was stripped of all valuables after its abandonment; all that remained were miscellaneous pipes and debris not worth salvaging and a few last vestiges of its once-glamorous interior decorations. (Both, PPL.)

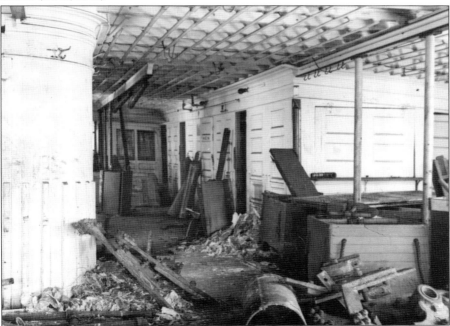

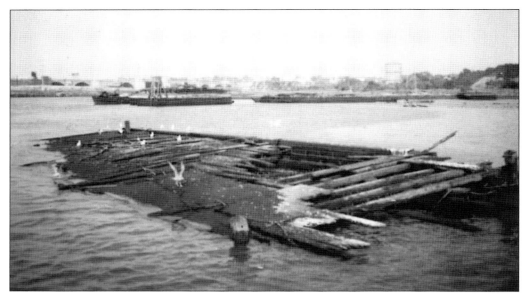

Green Jacket Shoal was firmly established as a place to dump derelict vessels throughout the 20th century. This sizable fragment of an old barge, floating loose in the Providence River in the 1960s, was towed to Green Jacket Shoal and tied onto the wreckage already there. (NAB.)

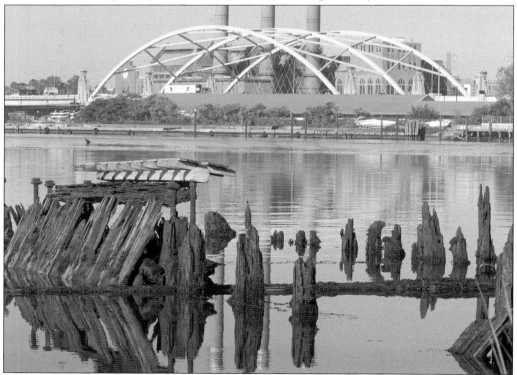

Remnants of the 29 shipwrecks known to have been abandoned at Green Jacket Shoal can still be seen looking west from the East Providence shoreline toward Providence on the other side of the river. (Joyce Gervasio.)

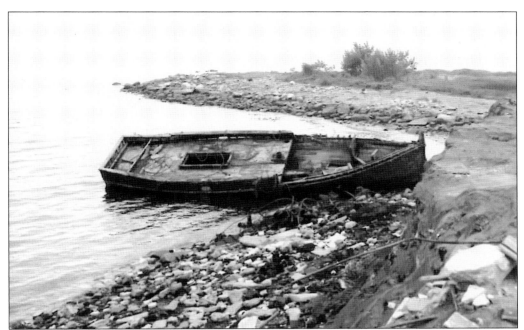

The fishing dragger *Stanley* was abandoned in Bullocks Point Cove, East Providence, after it sank in 1963 when its caulking came loose at the seams. After the owners tried unsuccessfully to raise her, she was formally abandoned. The US Army Corps of Engineers removed her on June 3–4, 1964, first burning the vessel on land and then hauling what remained, shown here, to the landfill for a cost of $1,200. (NAB.)

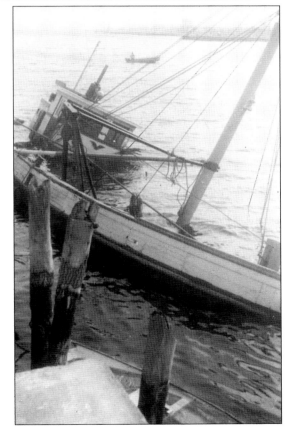

Abandoned boats were not just a public hazard to navigation, but a nuisance to private property owners. The fishing boat *I.E. Brown* was abandoned off a pier at 279 Water Street in Warren, much to the dismay of that property's owner. The Barrington police ordered the owner of the vessel several times to remove it, which he did not do. By March 1963, the vessel had become partially submerged, and the owner of the property called on the US Army Corps of Engineers to remove it, as it had become a navigational hazard and was in danger of leaking diesel fuel. (NAB.)

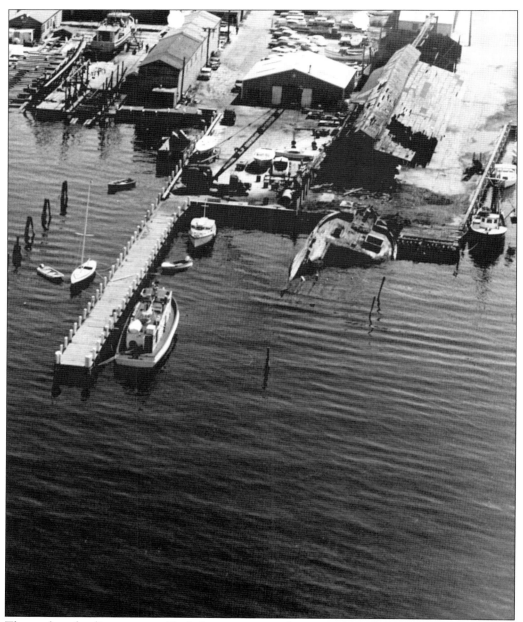

The sunken derelict gas screw *Tuckahoe* was an unwelcome guest at the Newport Shipyard after being abandoned there around 1950. In 1967, the shipyard asked the Corps to help remove it, but they concluded it was not a hazard to navigation and so was outside their purview. At that point, Sen. John O. Pastore used his influence to bring in a 15-man crew from Construction Battalion Regiment 21 at Davisville to demolish the vessel. Bill Ervin, the team supervisor, found it a challenge. "I've worked some tough jobs with the Seabees," Ervin said when interviewed for the *Newport Daily News* that June. "I've even captured two whales for the state of Rhode Island, but this baby isn't going to move easily." (NAB.)

Many wrecked vessels and fragments of vessels that hold few clues at best as to their identity still lie under the sand of Rhode Island's beaches. This unidentified vessel was briefly exposed in the early 20th century on Block Island's town beach, to the north of the ferry landing. (PPL.)

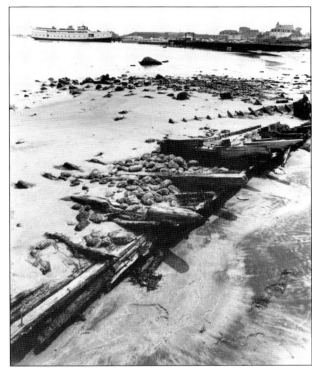

This wooden scow foundered, bottom side up, on the coast of Little Compton, half a mile north of Church Point. Plans were made to remove it, and it was surveyed by a diver in March 1971 to assess how intact it was. Visible drag marks on the bottom showed it had washed ashore from the south. The remains of the vessel broke up before it was removed. (NAB.)

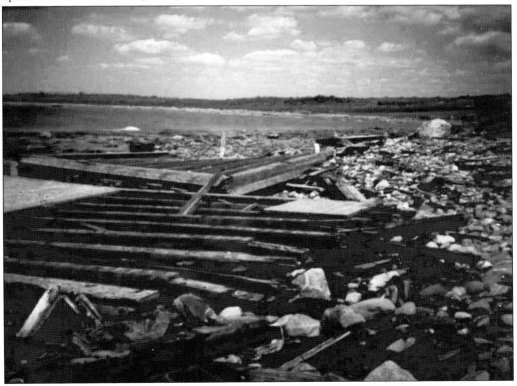

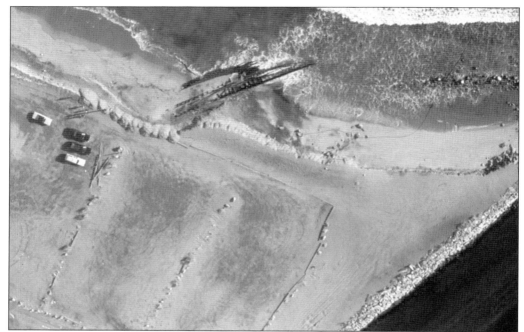

A substantial shipwreck, shown in this aerial photograph from the 1970s, lies next to the Charlestown Breechway. Every 20 years or so, the sand that generally covers it is washed away by a storm, and it excites local interest all over again. (RIHPHC)

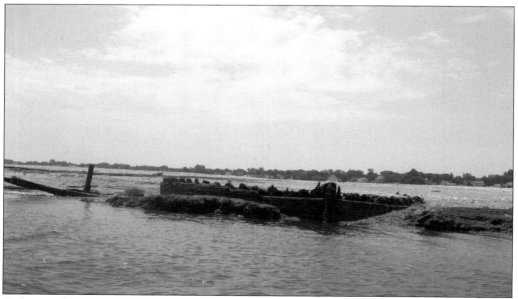

A shipwreck on Green Island in Warwick, shown here at low tide, is occasionally hailed as the 18th-century British vessel *Gaspee*, as it lies near to where the *Gaspee* was burned a few years before the Revolutionary War. However, it is a much more modern wreck—probably an old barge. (Rhode Island Marine Archaeology Project.)

Seven

EPILOGUE

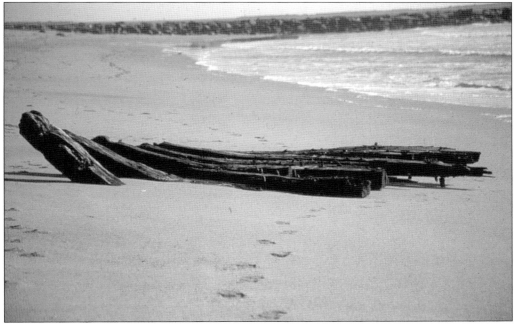

Shipwrecks and marine disasters are much less common now in Rhode Island than they once were. Modern aids to navigation have reduced the dangers of navigating in the fog and colliding with other vessels. When Roger Dunham, Westerly's shipwreck commissioner for 20 years, was interviewed by the *Panama City News* in February 1953, he commented that the only work he had done for this non-salaried position was to "think about it a couple of times." The *Altana M. Jagger*, run aground at Weekapaug Point in 1932 (see page 37), was the first and last wreck he visited. "There are no such things as marine wrecks any more. Not like there used to be. Why I can remember when 40 to 50 coastal trade vessels a day went by the point," Dunham recalled. A few scattered bits of ship are still uncovered on the beaches periodically during storms, drawing the curious to take a closer look, as these footprints in the sand show. (RIHPHC)

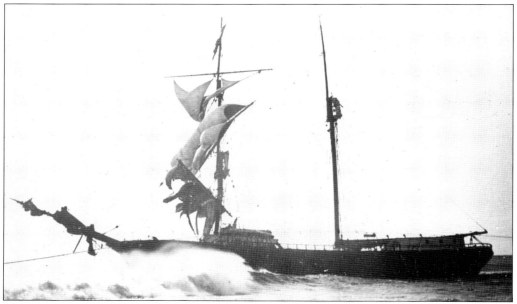

These remnants are no match for the iconic shipwrecks from the days of sail, like the wreck of the *Harry Knowlton*. (WHS.)

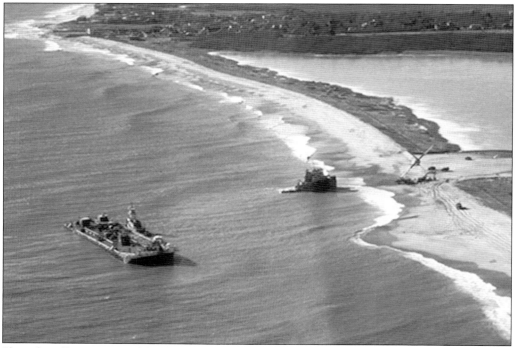

Ships do still run into trouble, like the *North Cape*, which went aground in a storm in January 1996 off South Kingstown. The tug *Skandia* was towing the *North Cape*, a tank barge full of heating oil, along the south coast of Rhode Island when its engine room caught fire. Both the *Skandia* and the *North Cape* ended up grounded off the beach, and an environmental disaster unfolded as thousands of gallons of heating oil flowed from the barge. (NOAA.)

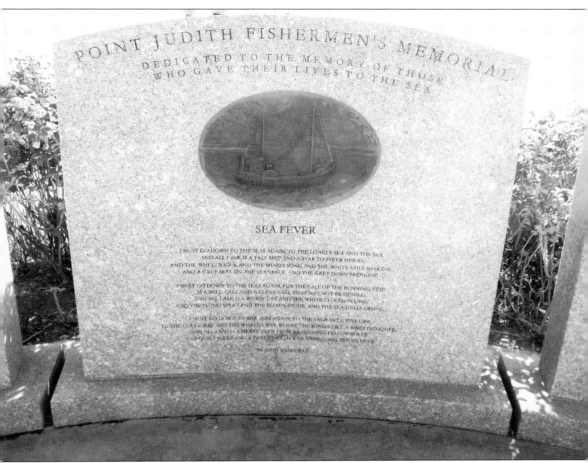

POINT JUDITH FISHERMEN'S MEMORIAL

DEDICATED TO THE MEMORY OF THOSE
WHO GAVE THEIR LIVES TO THE SEA

SEA FEVER

I MUST GO DOWN TO THE SEAS AGAIN, TO THE LONELY SEA AND THE SKY,
AND ALL I ASK IS A TALL SHIP AND A STAR TO STEER HER BY,
AND THE WHEEL'S KICK AND THE WIND'S SONG AND THE WHITE SAILS SHAKING,
AND A GREY MIST ON THE SEA'S FACE, AND THE GREY DAWN BREAKING.

I MUST GO DOWN TO THE SEAS AGAIN, FOR THE CALL OF THE RUNNING TIDE
IS A WILD CALL AND A CLEAR CALL THAT MAY NOT BE DENIED;
AND ALL I ASK IS A WINDY DAY AND THE WHITE CLOUDS FLYING,
AND THE FLUNG SPRAY AND THE BLOWN SPUME, AND THE SEA GULLS CRYING.

I MUST GO DOWN TO THE SEAS AGAIN, TO THE VAGRANT GYPSY LIFE,
TO THE GULL'S WAY AND THE WHALE'S WAY WHERE THE WIND'S LIKE A WHETTED KNIFE;
AND ALL I ASK IS A MERRY YARN FROM A LAUGHING FELLOW-ROVER,
AND QUIET SLEEP AND A SWEET DREAM WHEN THE LONG TRICK'S OVER.

BY JOHN MASEFIELD

It is to the credit of the US Life-Saving Service that the number of casualties from Rhode Island's shipwrecks, disasters out at sea like the *Metis* and *Larchmont* aside, is as low as it is. But though commercial traffic on the sea might be less than it once was, it still is not a safe place. The Fishermen's Memorial at Narragansett, in sight of the Point Judith lighthouse, is located at a vantage point where, on just about any day, one can still see fishing boats, passing freighters, and pleasure craft. Dedicated "to those who gave their lives to the sea," it is also a poignant reminder that accidents—sadly, sometimes fatal—can still happen out at sea. (RIHPHC.)

Discover Thousands of Local History Books
Featuring Millions of Vintage Images

Arcadia Publishing, the leading local history publisher in the United States, is committed to making history accessible and meaningful through publishing books that celebrate and preserve the heritage of America's people and places.

Find more books like this at
www.arcadiapublishing.com

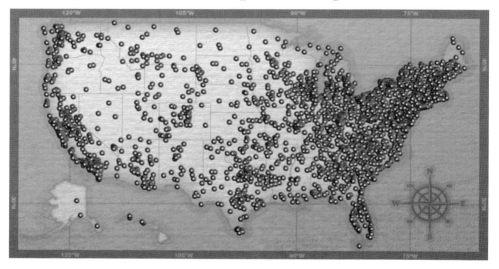

Search for your hometown history, your old stomping grounds, and even your favorite sports team.